creative

ACTIVITIES

Art
for all
Seasons

JOY EVANS
JO ELLEN MOORE

AGES
5-11

AUTHORS

Joy Evans

Jo Ellen Moore

CURRICULUM ADVISER

Alison Milford

SENIOR COMMISSIONING EDITOR

Juliet Gladston

ASSISTANT EDITOR

Tracy Kewley

DESIGNER

Helen Taylor

ILLUSTRATOR

Jo Larsen

PUBLISHED BY

Scholastic Ltd,

Villiers House,

Clarendon Avenue,

Leamington Spa,

CV32 5PR

www.scholastic.co.uk

This edition is published by arrangement with Evan-Moor Corporation, USA. Text © 2004 Evan Moor Corporation

© 2005 Scholastic Ltd

Designed using Adobe Indesign

Printed by Tien Wah Press, Singapore

1234567689 5678901234

British Cataloguing-in-Publication Data

A catalogue record from this book is available from the British Library.

ISBN 0-439-96525-X

ISBN 978-0-439-96525-5

Extracts from Programmes of Study from The National Curriculum reproduced under the terms of HMSO Guidance Note 8. © Qualifications and Curriculum Authority.

Introduction

Art is a very important element of a child's learning experience. It gives children a unique way to express themselves and it helps them to relate to culture and life around them. Most of all it is fun.

This art book aims to cover all these aspects through art activities linked to each of the four seasons of the year. There are activities linked to changes in nature, weather and landscapes, and to the seasonal activities that the children may experience. Each season also has its own set of festivals and special days and this book provides a range of activities that show how to make simple cards, decorations and gifts for many of these occasions.

The activities use a range of art techniques including printing, collage, three-dimensional paper constructions, painting, origami and pop-ups.

The book can be used in several ways:

- for activities related to one season
- for activities based on a topic such as a festival or seasonal weather
- for activities and skills based on specific art techniques such as paper folding
- to find an interesting art activity to support or use alongside another subject
- as a dip-in resource for a one-off lesson.

The activities can be approached in various ways depending on the age and ability of the children. For younger children you may want to cut out the templates and patterns on the photocopiable pages in advance in order for them to get the maximum benefit and enjoyment out of the activities. Older children could develop the activities by experimenting further with the techniques shown. You can also use the book as a resource for display ideas or to find ways of supporting another curriculum subject.

It is highly recommended that you do each activity in advance of the lesson to better anticipate any special assistance that may be needed.

AUTUMN

WINTER

SPRING

SUMMER

Using the activity pages

Each activity is broken down into the areas outlined below:

AGE RANGE

This section highlights the recommended age range. Most of the activities can be easily adapted for younger or older children.

MATERIALS

In this section, you will find a concise list of resources needed for each activity. All the resources are easy to obtain from suppliers or shops. Aim to get the resources ready and set out before the activity begins. Where card is suggested, you need thin card that can be easily folded.

CURRICULUM LINKS

This section gives direct links to the relevant Government documents such as the National Curriculum and the QCA Schemes of Work. These links can help you with the planning and assessment of future activities.

STEPS TO FOLLOW

This section gives step-by-step instructions for the art activity. Some of the instructions have detailed diagrams or illustrations.

PHOTOCOPIABLES

This section has photocopiable templates and patterns. They have clear labels and lines to indicate where to cut and trace.

Cross-Curricular Links

Many of the activities in the book link with other curriculum subjects. Work on festivals can be linked to PSHE, nature activities can be used alongside science topics such as minibeasts, and shapes and patterns can be used in maths. Many of the fun pictures and three-dimensional constructions in the book can be used for creative writing lessons. Display the written work alongside the finished art work for an attractive display.

Display

Creating pieces of art is a rewarding experience. Children have a sense of achievement when they see their finished work on display. It encourages them to discuss, compare and appreciate each other's individual creativity and perspective.

- Work can be displayed on both flat walls or moveable boards
- Window ledges, table tops and bookcases make excellent display areas for three-dimensional pieces.
- Large pieces such as papier-mâché animals or brooms can be displayed on a floor area. Mark out the area with masking tape or cloth. Set up blocks or stools to serve as stands for the art piece.
- Don't forget to label each piece with its title, the medium used, the artist's name and the date created.

Contents

During the season of autumn, the colours of nature start to change. From the greens of summer, reds, yellows and oranges start to appear on the trees. Leaves begin to fall and animals start to prepare for the cold winter.

There are also celebrations during the autumn season. The crops and fruit are harvested and many people hold a harvest festival to give thanks for the food. A cornucopia (see page 12) is used as a means to observe and draw harvest food.

At the end of October, some people celebrate Hallowe'en. The projects in this chapter include three-dimensional pumpkins, a moveable skeleton and a fun pumpkin seed smile monster.

The activities in this chapter cover many of these areas using a range of techniques such as paper cutting, tracing around templates to make a fun three-dimensional scarecrow, apple designs and pumpkin decorations.

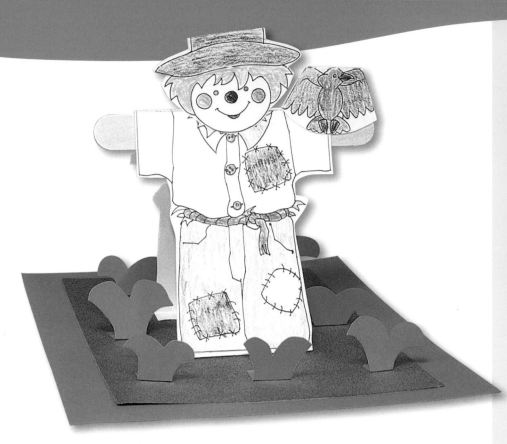

My scarecrow

STEPS TO FOLLOW

1. Colour in and cut out the pattern pieces.

2. Follow the folding instructions.

3. Fold the white card in half. Glue the scarecrow pattern to it, matching up the centre fold. Trim off the excess white card along each side. Fold under the extra white paper on the bottom to create flaps for glueing.

4. Use glue to secure the craft stick in the centre fold.

5. Glue on the scarecrow's head and the bird on his arm. Glue the two bottom flaps to the brown card base.

6. Glue the brown card to the green card.

7. Cut scraps of green paper to create sprouting plants and glue these around the scarecrow's feet.

AGE RANGE: 5-7 years

This happy scarecrow might not frighten the birds, but he is really simple to make. Encourage younger children to cut out and colour in the template without support. The scarecrow could be used as part of a harvest display or as a stimulus for creative writing.

MATERIALS

- a copy of photocopiable page 7 for each child

- 10 x 28 cm thin white card for the scarecrow

- 15 x 23 cm thin brown card for the base

- 20 x 25.5 cm thin green card for the frame

- scraps of green paper

- craft stick

- scissors

- glue

- crayons, felt-tip pens or coloured pencils

National Curriculum: Art & design
KS1: 2a, 2b, 4a, 4b, 5b, 5c
QCA Schemes: Art & design
Unit 1B – Investigating materials
Scottish 5-14 Guidelines: Art & design
Using materials, techniques, skills and media:
Using visual elements
Expressing feelings, ideas, thoughts and solutions; Creating and designing

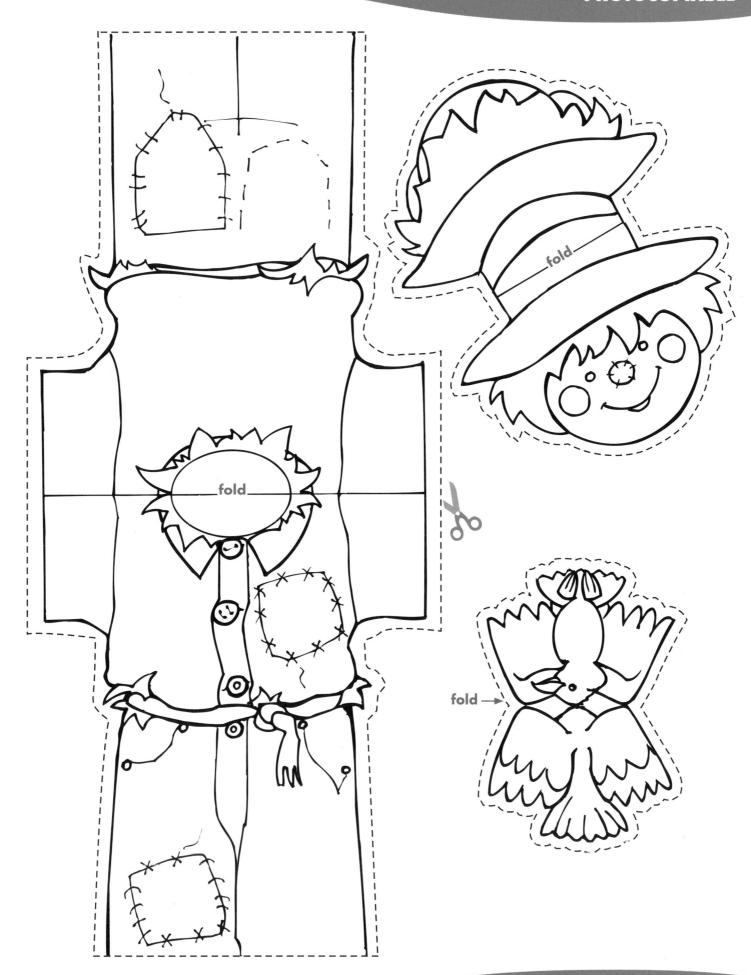

fold

fold

fold

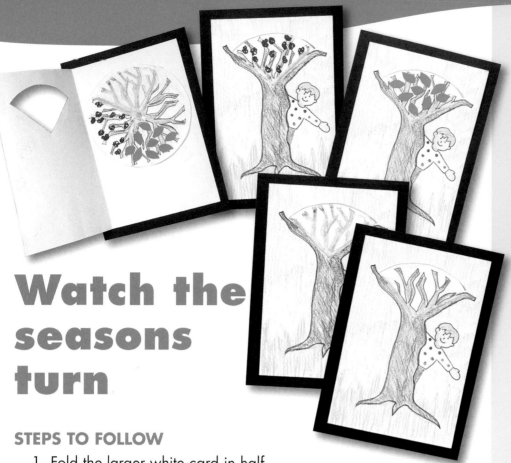

Watch the seasons turn

STEPS TO FOLLOW

1. Fold the larger white card in half.

2. Use the template to locate the area to be cut out. Trace around the triangular opening in pencil and then cut on the pencil line with a craft knife.

3. Using the template as a guide, mark dots that indicate where to insert the paper fastener through the centre of the wheel and then through the folded card. Insert the fastener and close the card.

4. Sketch a tree trunk on the front of the card. It should branch around the triangular opening. Add other details to the background.

5. Now sketch the bare branches of a winter tree inside the triangular window. Keep turning the wheel and drawing until you have drawn bare branches for each season of the year. Colour in the branches.

6. Turn the wheel to winter and add a triangle of white tissue paper to look like ice and snow.

7. Turn the wheel clockwise to spring and add colourful blossoms with felt-tip pens.

8. Turn the wheel again. For summer, add leaves cut from the scraps of green card.

9. Glue the finished art to the black card frame.

AGE RANGE: 5-11 years

This activity can be used to stimulate discussion and writing about seasonal changes. Younger children may need some support with the tree and wheel design but encourage older or more able children to design their own.

MATERIALS

- photocopiable pages 9 and 10
- 18 x 25 cm black card for the frame
- 23 x 30.5 cm white card
- 15 cm square of white card for the wheel
- scraps of green card
- white tissue paper
- paper fastener
- crayons, felt-tip pens or coloured pencils
- scissors
- craft knife
- pencil
- glue

National Curriculum: Art & design
KS1: 2a, 2b, 2c, 4a, 4b, 5b, 5c
QCA Schemes: Art & design
Unit 2B – Mother Nature, designer
Unit 3B – Investigating pattern
Scottish 5-14 Guidelines: Art & design
Using materials, techniques, skills and media:
Investigating visually and recording;
Using media; Using visual elements
Expressing feelings, ideas, thoughts
and solutions: Creating and designing;
Communicating

Cut out this window.

Insert paper
fastener here.

Insert paper
fastener here.

This simple activity offers another way of recording first-hand observations of objects. This activity can also be used as part of a design and technology or science project on the investigation of fruit and vegetables.

MATERIALS

- 15 cm square of black card for the background
- 12.5 cm square of red or yellow card
- 10 cm square of white card
- scraps of green card for the stem and leaf
- black beans
- scissors
- glue

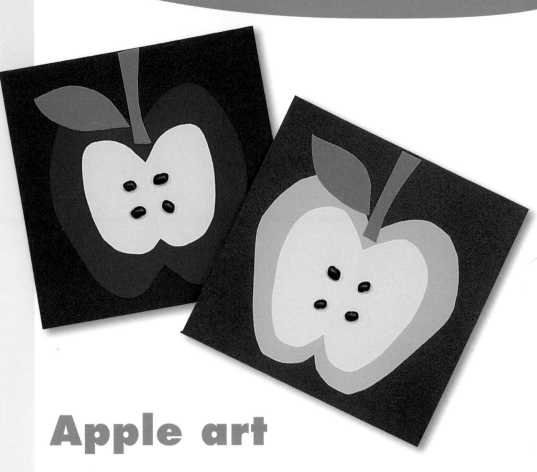

Apple art

STEPS TO FOLLOW

1. Fold the red or yellow card in half. Cut one-half of an apple shape on the fold.

2. Fold and cut the white paper in the same shape.

3. Glue the white shape to the coloured shape.

4. Cut a stem and a leaf from the green card.

5. Arrange all the pieces on the black square. Glue the pieces down.

6. Glue on black beans to represent seeds.

National Curriculum: Art & design
KS1: 1a, 2a, 2b, 4a, 4b, 5b, 5c
QCA Schemes: Art & design
Unit 2B – Mother Nature, designer
Scottish 5-14 Guidelines: Art & design
Using materials, techniques, skills and media:
Investigating visually and recording; Using media; Using visual elements
Expressing feelings, ideas, thoughts and solutions: Creating and designing

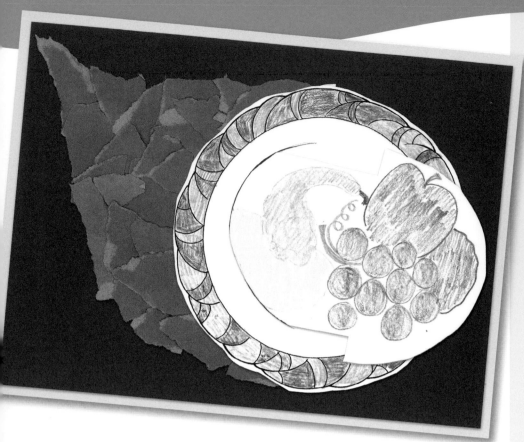

The Harvest cornucopia

STEPS TO FOLLOW

1. Cut out the pattern for the mouth of the basket and colour it in.

2. Glue the pattern to the black card.

3. Cut the slit as marked using a craft knife. Cut through both the pattern and the black card.

4. Draw a pencil line on the black card to outline the basket shape. Build the basket by tearing off bits of brown card and glueing them around the mouth of the basket. Begin glueing at the top of the basket and overlap the pieces as you work down.

5. Cut out the template and slip the white card strip into the slit in the mouth of the basket. On the strip, draw or create with cut paper all the fruits and vegetables we enjoy in the autumn. Slip the strip back into the cornucopia. Then pull the strip out again to show the abundance of the harvest.

6. Use a strip of double-sided sticky tape along the top of the black card to attach it to the yellow paper frame.

AGE RANGE: 5-11 years

The word 'cornucopia' means 'horn of plenty'. Discuss why a cornucopia is often made at harvest time. With the children make a list of fruits and vegetables that could be put in their harvest cornucopias.

MATERIALS

- photocopiable pages 13 and 14

- 23 x 30.5 cm white card to create the cornucopia pull-out

- 23 x 30.5 cm black card for the background

- 15 x 30.5 cm brown card for the basket

- 24 x 32 cm yellow card for the frame

- craft knife

- scissors

- glue

- double-sided sticky tape

- crayons, felt-tip pens or coloured pencils

National Curriculum: Art & design
KS1: 2a, 2b, 2c, 4a, 4b, 5b, 5c
KS2: 2a, 2b, 2c, 4a, 4b, 5b, 5c

QCA Schemes: Art & design
Unit 1B – Investigating materials
Unit 2B – Mother Nature, designer

Scottish 5-14 Guidelines: Art & design
Using materials, techniques, skills and media:
Investigating visually and recording; Using media; Using visual elements
Expressing feelings, ideas, thoughts and solutions; Creating and designing; Communicating

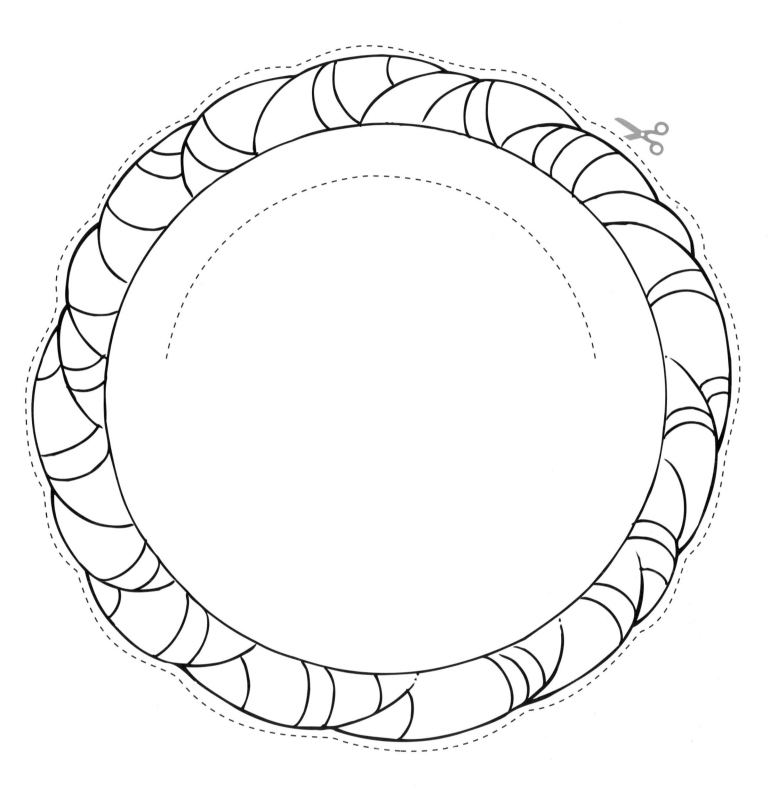

Cornucopia pull-out (white)

Creative Activities • Art for all Seasons • **www.scholastic.co.uk**

AGE RANGE:
5-11 years

Children will have great fun drawing different facial expressions for their Hallowe'en cats. Using a long strip, encourage the children to draw a wide range of expressions. This activity could be used as a springboard for creative writing sessions.

MATERIALS

- 23 cm square of white card
- 10 x 45.5 cm strip of white card
- 25.5 cm square of blue card for the frame
- crayons or felt-tip pens
- scissors or craft knife
- ruler

National Curriculum: Art & design
KS1: 1a, 2a, 2b, 2c, 4a, 4b, 5b, 5c
KS2: 1a, 2a, 2b, 2c, 4a, 4b, 5b, 5c
QCA Schemes: Art & design
Unit 1A – Self portrait
Unit 6A – People in action
Scottish 5-14 Guidelines: Art & design
Using materials, techniques, skills and media:
Using media; Using visual elements
Expressing feelings, ideas, thoughts
and solutions: Creating and designing;
Communicating

The changeable cat

STEPS TO FOLLOW

1. Cut two 11.5 cm vertical slits in the white card as shown.

2. Sketch the cat's head around the slits. Colour in the head using the side of a broken black crayon.

3. Slip the white card strip through the slits. Pull the strip all the way to one side. Sketch the face of the character on the first section of the strip.

4. Pull the strip to the next section. Draw the face again, showing a change of expression. Keep moving the strip and drawing until four different expressions are shown.

5. Add colour to the pull strip.

6. Add details and colour to the area around the outside of the cat's head. A colourful, repetitive border adds interest.

7. Glue the top and the bottom of the white paper to the blue card frame. Make sure that the area in the middle is free of glue so the card strip moves freely.

7.5 cm

11.5 cm

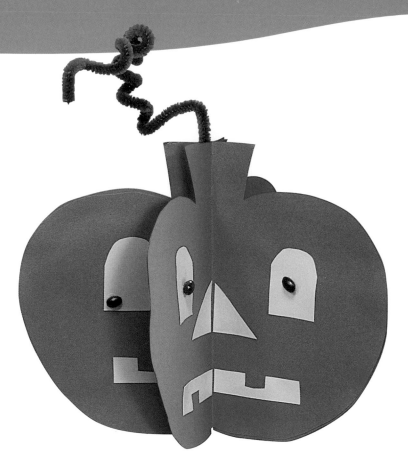

Jack-o'-lantern pals

AGE RANGE: 5-11 years

These jack-o'-lanterns have simple templates for children to trace around, cut out and make without too much support. The jack-o'-lantern pals can be used in the classroom or at home as table or window decorations.

MATERIALS

- photocopiable page 17
- four 15 x 20 cm orange card pieces for the pumpkins
- four 2.5 x 15 cm yellow card strips
- green pipe cleaner
- pencil
- black beans or seeds
- scissors
- glue

STEPS TO FOLLOW

1. Trace around the pumpkin template on the orange card and cut out four pumpkins.

2. Cut the yellow strips as shown to create the pumpkin faces. Glue the pieces in place.

nose mouth eyes

3. Glue on the black beans or seeds for eyes. Place the beans or seeds in a different position on each pumpkin.

4. Fold each pumpkin in half.

5. Glue the pumpkins back to back.

6. Slip the pipe cleaner between the stems and curl it.

National Curriculum: Art & design
KS1: 2a, 2b, 4a, 4b, 5b, 5c
KS2: 2a, 2b, 4a, 4b, 5b, 5c
QCA Schemes: Art & design
Unit 1B – Investigating materials
Unit 3B – Investigating pattern
Scottish 5-14 Guidelines: Art & design
Using materials, techniques, skills and media:
Using media; Using visual elements
Expressing feelings, ideas, thoughts and
solutions: Creating and designing

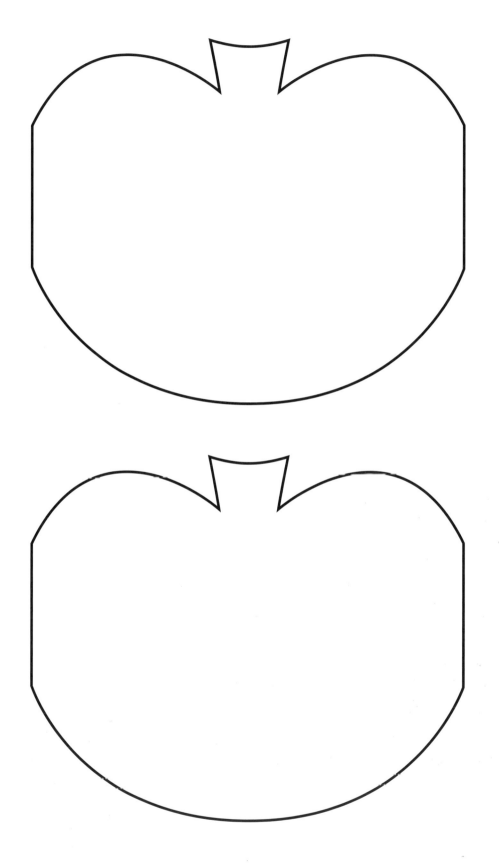

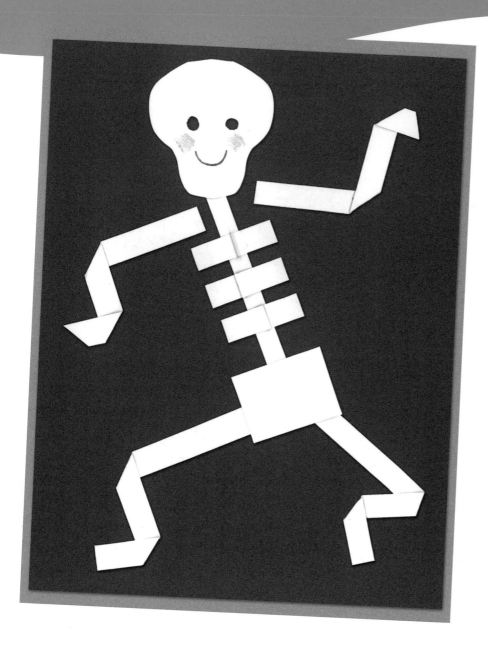

AGE RANGE: 5-11 years

Through the art of paper folding, this fun activity investigates the different movements of a skeleton. Encourage the children to make several versions, each in a different position. This activity is a great springboard for creative writing sessions.

MATERIALS

- a copy of photocopiable page 19 for each child

- 21.5 x 28 cm black card for the background

- 23 x 30.5 cm orange card for the frame

- hole punch

- scissors

- glue

- gel pens or crayons

Silly skeleton

STEPS TO FOLLOW

1. Cut out the pattern pieces.

2. Use the hole punch to make eye sockets.

3. Glue the various body parts to the black card. Begin with the skull and spine. Add the ribs by putting glue on each end and letting the centre of the strip buckle up. Bend the leg and arm strips at the joints before glueing them down.

4. Glue the black card to the orange frame.

5. Glue the poem to the back of the skeleton and read it together.

National Curriculum: Art & design
KS1: 2a, 2b, 2c, 4a, 4b, 5b, 5c
KS2: 2a, 2b, 2c, 4a, 4b, 5b, 5c
QCA Schemes: Art & design
Unit 1B – Investigating materials
Unit 6A – People in action
Scottish 5-14 Guidelines: Art & design
Using materials, techniques, skills and media:
Using media; Using visual elements
Expressing feelings, ideas, thoughts
and solutions: Creating and designing;
Communicating

Glue this poem to the back of the skeleton.

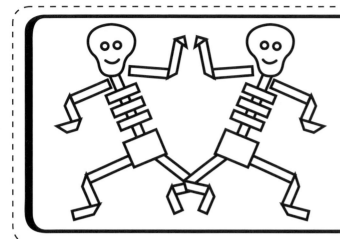

My skeleton,
My bony, bony skeleton
Keeps me standing tall.
Without my bony skeleton,
All my parts would fall.

Limbs

Head

Ribs

Pelvis

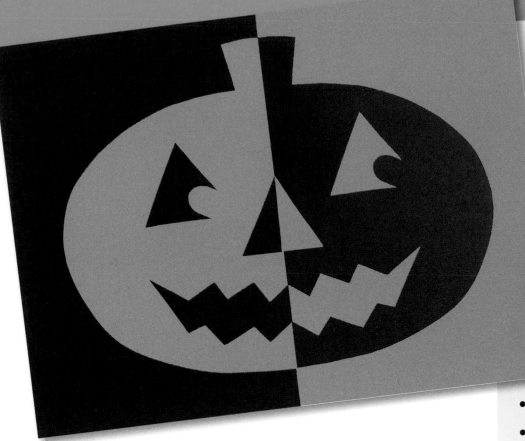

Positive-negative pumpkins

AGE RANGE:
7-11 years

This activity encourages children to investigate the effective use of positive-negative images often used in printing. The positive-negative pumpkins could also be used as a fun Hallowe'en maths activity.

MATERIALS

- 15 x 23 cm orange card
- 23 x 30.5 cm black card
- glue
- scissors
- pencil

STEPS TO FOLLOW

1. Lay the orange card on the right side of the black card. Draw one half of a pumpkin shape, including one eye, half a nose and half a mouth on the orange card. Make the shapes simple for easy cutting.

2. Cut out the pumpkin shape. Carefully cut out the eye, nose and mouth and lay the pieces to one side.

3. Flip the pumpkin shape over to the left and lay the cut-out pieces on the right hand side as shown.

National Curriculum: Art & design
KS2: 2a, 2b, 4a, 4b, 5b, 5c
QCA Schemes: Art & design
Unit 3B – Investigating pattern
Scottish 5-14 Guidelines: Art & design
Using materials, techniques, skills and media:
Using media; Using visual elements
Expressing feelings, ideas, thoughts and
solutions: Creating and designing

This activity shows children how to turn a simple idea into a fun picture using three-dimensional paper construction. Highlight the use of pumpkin seeds to make effective smiles. You could follow up the activity with a writing session about the different creatures.

MATERIALS

- 20 x 28 cm white card
- 15 cm square of yellow card
- 23 x 30.5 cm black card for the frame
- pumpkin seeds
- tempera paint and sponge pieces
- shallow dishes
- scissors
- glue
- fine-point felt-tip pens
- pencil

National Curriculum: Art & design
KS1: 1a, 2a, 2b, 2c, 4a, 4b, 5b, 5c
KS2: 1a, 2a, 2b, 2c, 4a, 4b, 5b, 5c
QCA Schemes: Art & design
Unit 1B – Investigating materials
Unit 2B – Mother Nature, designer
Scottish 5-14 Guidelines: Art & design
Using materials, techniques, skills and media:
Using media; Using visual elements
Expressing feelings, ideas, thoughts and
solutions: Creating and designing

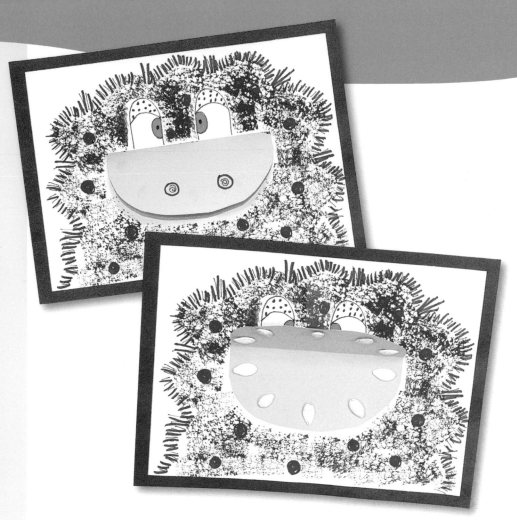

Pumpkin seed smile

STEPS TO FOLLOW

1. Fold the yellow square of card in half. Round the corners as shown.

2. Lay the folded circle on the white card. Think of a character. The folded part is its mouth. Sketch the outline of the character lightly in pencil.

3. Sponge paint inside the character outline. Let it dry thoroughly.

4. Glue the mouth in place.

5. Use the felt-tip pens to add colour and detail.

6. Glue the pumpkin seeds inside the character's mouth.

7. Add the black card frame.

Contents

The coming of winter usually brings in the cold weather. This chapter includes three-dimensional paper constructions to illustrate winter activities and sights such as tobogganing and snowmen.

The winter season is traditionally a time for making gifts, cards and decorations for the important festivals and special occasions during this period. Hanukkah and Divali are both festivals of light and use candles as part of their celebrations. Christmas, Chinese New Year and Valentine's Day are other important winter festivals.

This chapter includes attractive, original and fun art projects for most of these festivals. Decorations, cards and gifts are made using a range or techniques such as paper folding, paper construction, colour patterns, symmetrical stencil designing, finger printing and weaving.

Creative Activities • Art for all Seasons • **www.scholastic.co.uk**

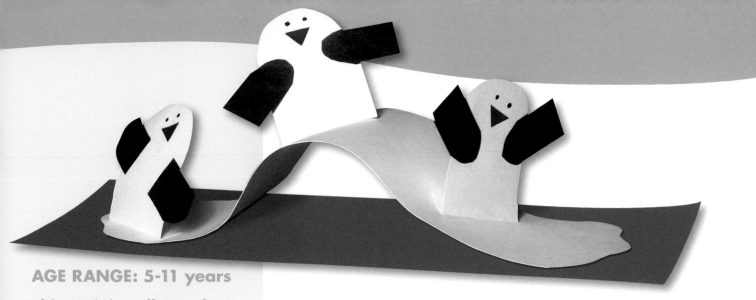

AGE RANGE: 5-11 years

This activity allows the children to develop skills in working on three-dimensional paper structures. Encourage them to experiment with the shape of the ice floe and the positions of the different penguins.

MATERIALS

- 7.5 x 30.5 cm white card strip for the ice floe

- 12.5 x 30.5 cm blue card for the sea

- three 5 x 9 cm white card pieces for the penguins' bodies

- three 2.5 x 7.5 cm black card strips for the penguins' wings

- crayons, felt-tip pens or coloured pencils

- glue and scissors

National Curriculum: Art & design
KS1: 2a, 2b, 3b, 4a, 4b, 5b, 5c
KS2: 2a, 2b, 3b, 4a, 4b, 5b, 5c
QCA Schemes: Art & design
Unit 1B – Investigating materials
Unit 6A – People in action
Scottish 5-14 Guidelines: Art & design
Using materials, techniques, skills and media:
Using media; Using visual elements
Expressing feelings, ideas, thoughts
and solutions: Creating and designing;
Communicating

Penguin playground

STEPS TO FOLLOW

1. Trim the ends of the white strip as shown. Apply a spot of glue to each end. Lay the white card on the blue card, leaving a hump in the middle. Hold down the glued ends until dry.

2. Round off the top corners of the three penguin bodies. Fold up a 0.6 cm flap on the bottom of each one.

3. Cut each of the black wing strips in half. Round off two of the corners on each. Experiment with different ways to place the wings on the bodies.

4. Add the eyes and beak with crayons, felt-tip pens or coloured pencils. Now glue the wings in place.

5. Apply glue to the flap on the bottom of each penguin. Place them on the white ice flow, holding them in place until the glue is dry enough to hold.

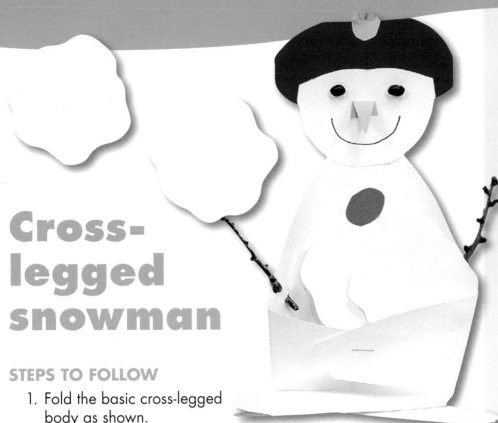

Cross-legged snowman

STEPS TO FOLLOW

1. Fold the basic cross-legged body as shown.

a.

Fold into middle.

b.

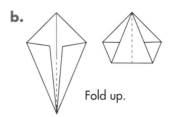

Fold up.

c.

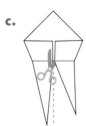

Open out and cut up to the fold.

d.

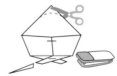

Cross over the legs and staple.
Staple the pocket. Trim off the points.

2. Use the template to cut several snowballs from the white card. Use one of these for the snowman's head.

3. Cut a red hat, using the template as a guide. Cut the slit as shown with a craft knife and slip it over the top of the snowman's head. Glue it in place.

4. Add the black beans or seeds for eyes and other details to the head and hat with cut card and felt-tip pens or coloured pencils.

5. Glue the head to the top of the body.

6. Round off the tips of the snowman's feet.

7. Punch two holes on each side of the body. Insert the twigs for arms.

AGE RANGE: 5-11 years

This activity uses simple origami techniques to make a fun cross-legged snowman. Make the main body for younger children and let them trace and cut out the head and snowball templates. Encourage older children to follow the folding instructions.

MATERIALS

- photocopiable page 25
- 23 cm square of white card for basic cross-legged body
- several 7.5 cm squares of white card for the head and snowballs
- 5 x 10 cm red card for the hat
- 5 cm squares of yellow and blue card for adding details
- two black beans or seeds
- two twigs
- hole punch
- craft knife or scissors
- glue
- crayons, felt-tip pens or coloured pencils
- stapler

National Curriculum: Art & design
KS1: 2a, 2b, 4a, 4b, 5b, 5c
KS2: 2a, 2b, 4a, 4b, 5b, 5c
QCA Schemes: Art & design
Unit 1B – Investigating materials
Unit 5B – Containers
Scottish 5-14 Guidelines: Art & design
Using materials, techniques, skills and media:
Using media; Using visual elements
Expressing feelings, ideas, thoughts and
solutions: Creating and designing

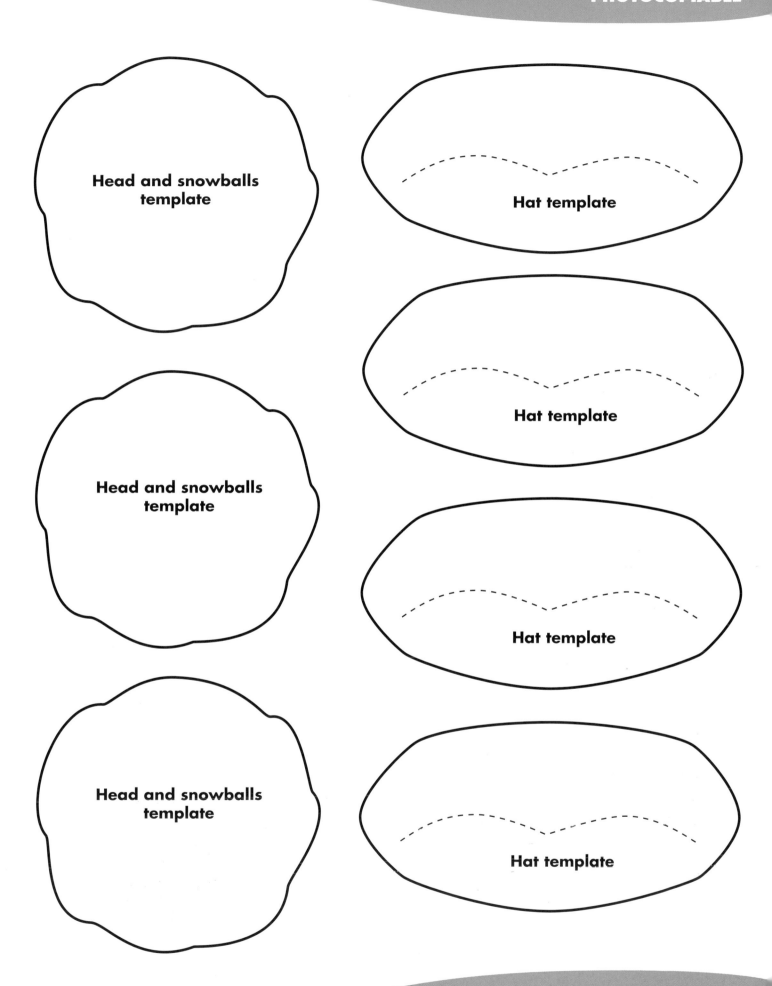

Head and snowballs template

Hat template

Head and snowballs template

Hat template

Head and snowballs template

Hat template

Hat template

Positive-negative trees

This activity allows children to experiment with different patterns and colours. Encourage the children to extend the range of patterns by discussing different tree shapes. This activity can be used as a fun Christmas or winter maths lesson.

MATERIALS

- photocopiable page 27
- 15 x 23 cm coloured card for the background
- 7.5 x 23 cm white card
- 18 x 25.5 cm black card for the frame
- scissors
- glue
- pencil

STEPS TO FOLLOW

1. Lay a template on the lower edge of the white card. Trace around the template. Cut on those lines. Keep the cut-out shapes in a pile.

2. Glue what is left of the white card to the top edge of the coloured paper.

3. Arrange the cut-out pieces back into their original place in the white card. Apply glue to each shape and then flip them over and place them so the bottom edges are touching. Continue until all the shapes have been turned over.

National Curriculum: Art & design
KS1: 2a, 2b, 2c, 4a, 4b, 5b, 5c
KS2: 2a, 2b, 2c, 4a, 4b, 5b, 5c
QCA Schemes: Art & design
Unit 2B – Mother Nature, designer
Unit 3B – Investigating pattern
Scottish 5-14 Guidelines: Art & design
Using materials, techniques, skills and media:
Investigating visually and recording; Using media; Using visual elements
Expressing feelings, ideas, thoughts and solutions: Creating and designing; Communicating

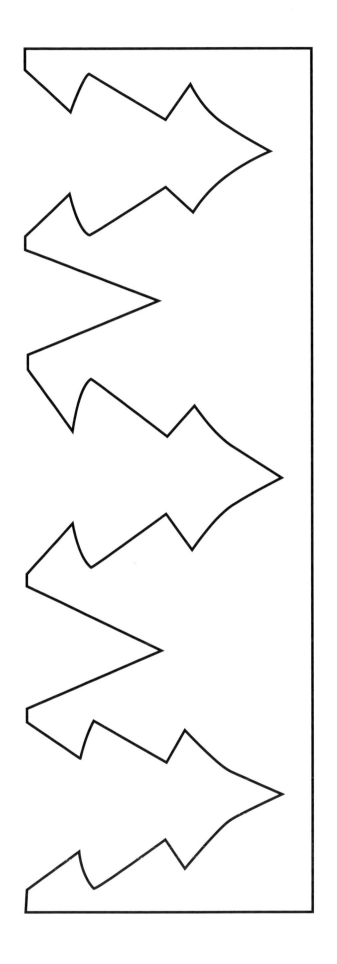

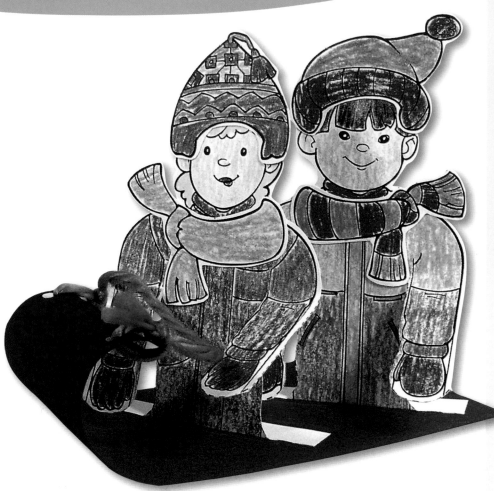

Toboggan kids

STEPS TO FOLLOW

1. Roll one end of the red card around a pencil to create the front of the toboggan.

2. Colour in all the patterns.

3. Glue the kid patterns to the white card, and then cut them out.

4. Glue on the hats and scarves.

5. Fold the patterns on the fold line. Apply glue to the flaps and place them on the toboggan. Hold in place until the glue dries.

6. Punch a hole on each side of the rolled front of the toboggan. Insert the wool on each side and tie in a knot. Glue the wool in the hands of the first kid.

AGE RANGE: 5-7 years

This simple but effective three-dimensional model can be made without much support. It develops cutting, colouring and sticking skills. Make a white hill out of card and put the toboggan kids on it as a display.

MATERIALS

- a copy of photocopiable page 29 for each child

- 10 x 23 cm red card for the sled

- 19 x 16.5 cm white card for the backing of the kids

- crayons, felt-tip pens or coloured pencils

- pencil

- scissors

- glue

- hole punch

- 25.5 cm of wool or string

National Curriculum: Art & design
KS1: 2a, 2b, 4a, 4b, 5b, 5c

QCA Schemes: Art & design
Unit 1B – Investigating materials

Scottish 5-14 Guidelines: Art & design
Using materials, techniques, skills and media:
Using media; Using visual elements
Expressing feelings, ideas, thoughts and
solutions: Creating and designing

Kids

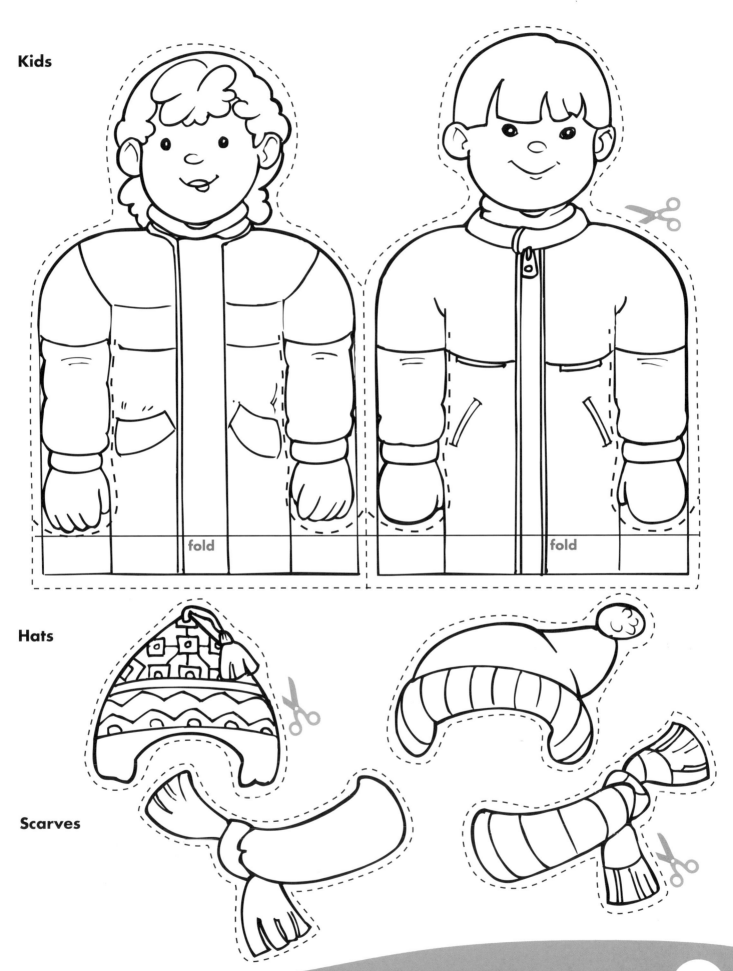

fold

fold

Hats

Scarves

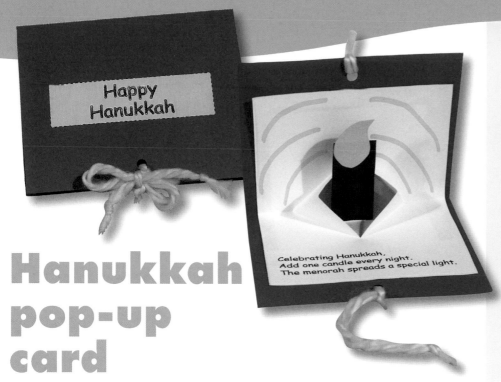

Celebrating Hanukkah.
Add one candle every night.
The menorah spreads a special light.

Hanukkah pop-up card

STEPS TO FOLLOW

1. Follow the cutting and folding directions on the patterns.

Pop-up A

a. b.

c. d.

Pop-up B

a. b.

c. d.

2. Add colour and designs to pop-up B.

3. Fold the blue outside folder in half. Lay pop-up A into the fold. Apply glue to the exposed side of the pop-up. Close the folder and press firmly. Flip the folder over. Open and apply glue to the other side of the pop-up. Close the folder and press. Allow to dry. Follow the same steps to glue pop-up B on top of pop-up A.

4. Open the pop-up. Apply glue to the pop-up tab on pop-up A. Place the red paper candle against the tab. Close the pop-up and press firmly again. Allow to dry.

5. Cut a flame from the yellow card and glue to the candle.

6. Punch two holes in the outside edges of the folder. Tie one end of the wool into each hole. Tie the two free ends in a bow.

7. Colour in and cut out the label for the outside of the card. Glue it in place.

AGE RANGE: 7-11 years

During the winter season, many different religions have festivals of lights. Both the Divali and Hanukkah festivals use candles to highlight the importance of light. This Hanukkah activity shows how to make a simple pop-up card.

MATERIALS

- a copy of photocopiable page 31 for each child
- 14 x 23 cm blue card for the outside folder
- 2.5 x 5 cm red card for the candle
- 2.5 x 4 cm yellow card for the flame
- hole punch
- yellow string or wool
- scissors
- glue

National Curriculum: Art & design
KS2: 2a, 2b, 4a, 4b, 5b, 5c
QCA Schemes: Art & design
Unit 1B – Investigating materials
Scottish 5-14 Guidelines: Art & design
Using materials, techniques, skills and media:
Using media; Using visual elements
Expressing feelings, ideas, thoughts and
solutions: Creating and designing

Pop-up A

Happy Hanukkah

Pop-up B

Celebrating Hanukkah,
Add one candle every night.
The menorah spreads a special light.

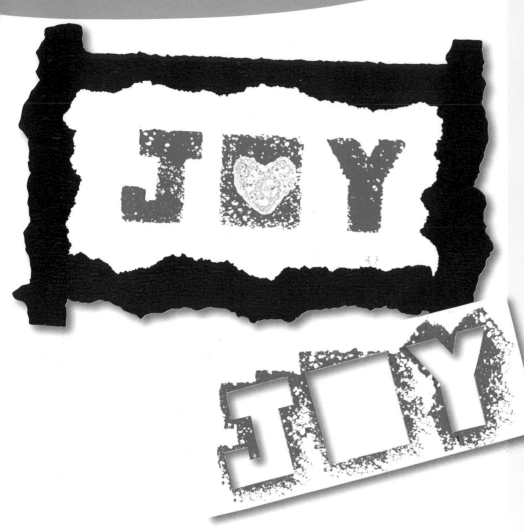

This activity shows how to make a simple stencil and its many uses as a printing tool. The JOY stencil can be used to make decorations, cards and even wrapping paper. Encourage children to think of other details they could add to their designs.

MATERIALS

- photocopiable page 33
- 12.5 x 23 cm thin card for the background
- 7.5 x 18 cm thick card for the stencil
- 15 x 23 cm coloured card for the frame
- assorted colours of tempera paint
- shallow dishes
- small rectangular sponges, some cut into heart shapes
- pencil
- craft knife
- glue

Stencil it

STEPS TO FOLLOW

1. Trace the stencil pattern onto the thick card. Cut it out with a craft knife. Make several copies of each stencil. It is best to make one for each colour of paint you plan to use.

2. Lay the stencil on the background card. Pour some paint into shallow dishes. Dip the sponge in the paint and dab it on the stencil. Gently lift off the stencil to see the result. Let the paint dry thoroughly.

3. Add other details to the design, such as a heart sponge print in the centre of the O in JOY.

4. Rip around the edge of the stencilled card to create a torn edging. Then tear the frame paper into four strips. Lay them around the edges of the background paper as the frame. Glue in place.

National Curriculum: Art & design
KS1: 2a, 2b, 2c, 4a, 4b, 5b, 5c
KS2: 2a, 2b, 2c, 4a, 4b, 5b, 5c
QCA Schemes: Art & design
Unit 1B – Investigating materials
Unit 3B – Investigating pattern
Scottish 5-14 Guidelines: Art & design
Using materials, techniques, skills and media:
Investigating visually and recording; Using media; Using visual elements
Expressing feelings, ideas, thoughts and solutions: Creating and designing

Joy

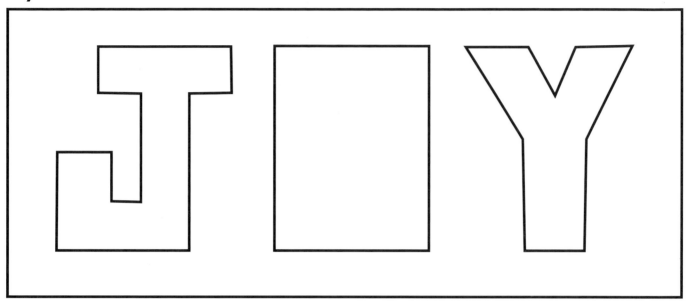

Holly

Star

Reindeer card holder

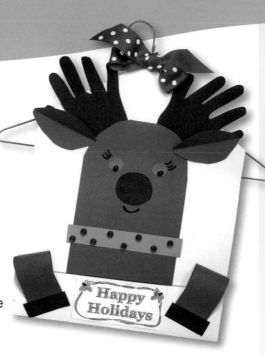

This card holder can be used in the classroom or given as a festive gift.

STEPS TO FOLLOW

1. Fold the corners of the white card over the wire hanger and tape in place.

2. Fold up 7.5 cm of the lower edge of the white paper and tape at the edges.

3. Round two corners of the large brown card for the reindeer's head. Lay it on the holder with the bottom slipped inside the folded-up section.

4. Trace around a child's hand on the dark brown card. Hold the two pieces of card together and cut on the pencil line. Lay the antlers on the holder. Slip them under the brown head piece.

5. Draw a leaf shape on the brown card for ears. Hold both pieces together and cut on the line. Fold the ears in half as shown and lay them on the reindeer's head.

6. Lay the piece for the collar where you think it works best.

7. Cut out circles for the eyes and nose and lay in place.

8. Adjust all the pieces you have cut and decide on the arrangement that you like the best. Now glue all the pieces in place.

9. Bend the pieces for the legs to fit in the pocket. Tape the legs in place. Add black hooves cut from paper scraps.

10. Children may like to decorate the pocket label on the pattern page. Cut it out and glue it to the pocket as shown.

11. Glue on the black beans for the eyes and glue the beads on the collar. Add details using a black marker.

12. Tie a bow on the top of the hanger.

Step 1

Step 2

Step 5

MATERIALS

- a copy of photocopiable page 35 for each child
- wire hanger
- 30.5 x 45.5 cm white card for the holder
- 15 x 30.5 cm brown card for the head
- two 7.5 x 10 cm brown card pieces for the ears
- two 5 x 15 cm brown card pieces for the legs
- two 15 cm squares of dark brown card for the antlers
- 6 cm square of red card for the nose
- scraps of black card
- two 2.5 cm squares of blue card for the eyes
- 2.5 x 16.5 cm green card for the collar
- two black beans
- eight red beads
- festive holiday ribbon
- pencil and marker pen
- tape

National Curriculum: Art & design
KS1: 2a, 2b, 4a, 4b, 5b, 5c
KS2: 2a, 2b, 4a, 4b, 5b, 5c
QCA Schemes: Art & design
Unit 1B – Investigating materials
Scottish 5-14 Guidelines: Art & design
Using materials, techniques, skills and media: Using media; Using visual elements
Expressing feelings, ideas, thoughts and solutions: Creating and designing

Pocket label

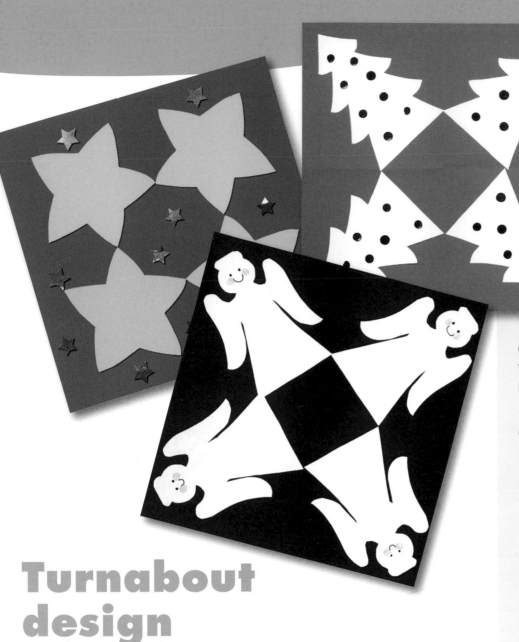

AGE RANGE:
5-11 years

This activity is very simple and eye-catching. Children can experiment and discover how different patterns and shapes can affect a design. The design would also make a fun maths activity.

MATERIALS

- photocopiable page 37
- four 10 x 12.5 cm card pieces for the figures
- 23 cm square of coloured card for the base
- scissors
- pencil
- glue
- paint, stickers and felt-tip pens for adding details

Turnabout design

STEPS TO FOLLOW

1. Trace the template onto the four pieces of card. Cut on the lines.

2. Fold the coloured card base into quarters.

3. Lay one pattern piece in each quarter, rotating the base around the centre point. The corners or tips of each pattern should just touch. Glue them in place.

4. Add details using your medium of choice.

National Curriculum: Art & design
KS1: 2a, 2b, 2c, 4a, 4b, 5b, 5c
KS2: 2a, 2b, 2c, 4a, 4b, 5b, 5c

QCA Schemes: Art & design
Unit 2C – Can buildings speak?
Unit 3B – Investigating pattern

Scottish 5-14 Guidelines: Art & design
Using materials, techniques, skills and media:
Using media; Using visual elements
Expressing feelings, ideas, thoughts
and solutions: Creating and designing;
Communicating

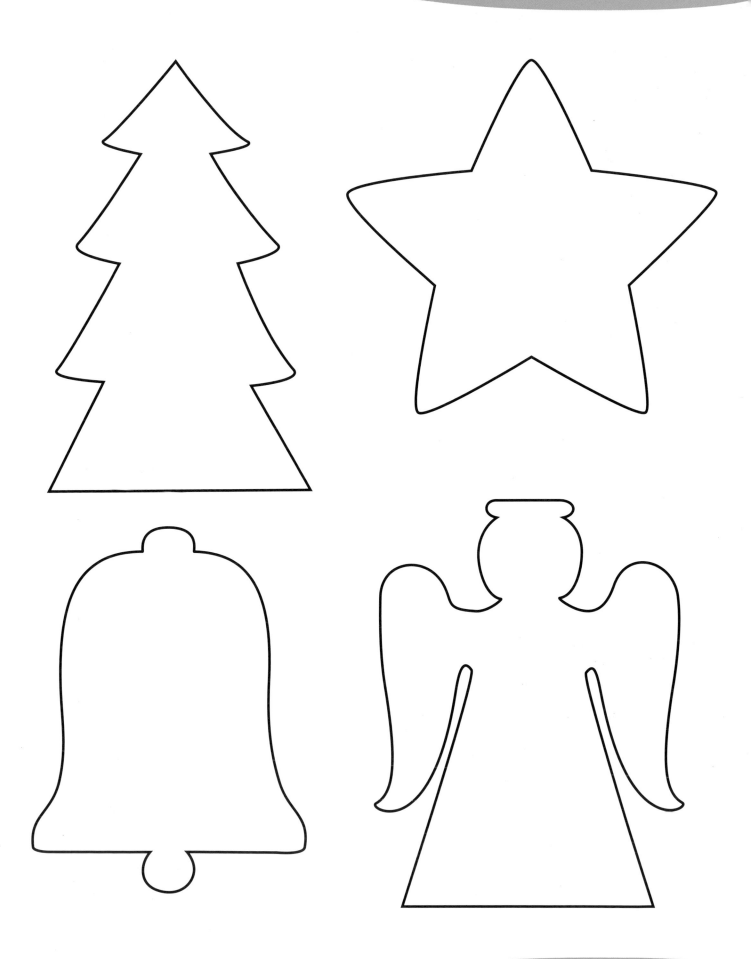

Little drummer boy

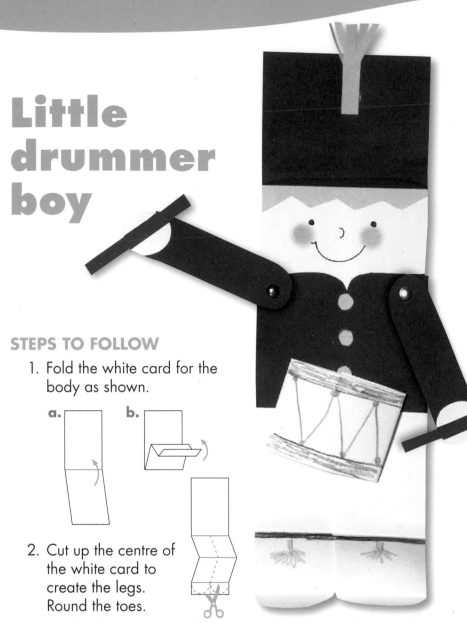

STEPS TO FOLLOW

1. Fold the white card for the body as shown.

 a. b.

2. Cut up the centre of the white card to create the legs. Round the toes.

3. Cut the hat and jacket from the red card using the templates as a guide. Fold up a visor on the hat.

4. Cut the hair from the yellow card using the template as a guide.

5. Glue the hair, jacket and hat pieces to the body as shown.

6. Cut the arm pieces from red card using the template as a guide.

7. Attach the arms with the paper fasteners.

8. Decorate the drum strip. Roll and glue it into a cylinder. Glue it to the front of the jacket.

9. Cut two hands and drumsticks from scraps of card. Glue them to the arms of the jacket.

10. Add facial features and other details with crayons, felt-tip pens, coloured pencils or paper scraps.

AGE RANGE: 5-11 years

The little drummer boy is made from simple paper folding techniques. Children can add the different parts of the drummer boy by cutting out and decorating templates. Let the children personalize the faces to look like themselves.

MATERIALS

- photocopiable page 39
- 10 x 30.5 cm white card for the body
- 15 x 20 cm red card for the hat and jacket
- 5.5 x 18 cm white card for the drum
- 5 x 10 cm yellow card for the hair and trim
- paper scraps for details
- two paper fasteners
- crayons, felt-tip pens or coloured pencils
- glue
- scissors

National Curriculum: Art & design
KS1: 2a, 2b, 2c, 4a, 4b, 5b, 5c
KS2: 2a, 2b, 2c, 4a, 4b, 5b, 5c
QCA Schemes: Art & design
Unit 1A – Self portrait
Unit 1B – Investigating materials
Scottish 5-14 Guidelines: Art & design
Using materials, techniques, skills and media:
Using media; Using visual elements
Expressing feelings, ideas, thoughts
and solutions: Creating and designing;
Communicating

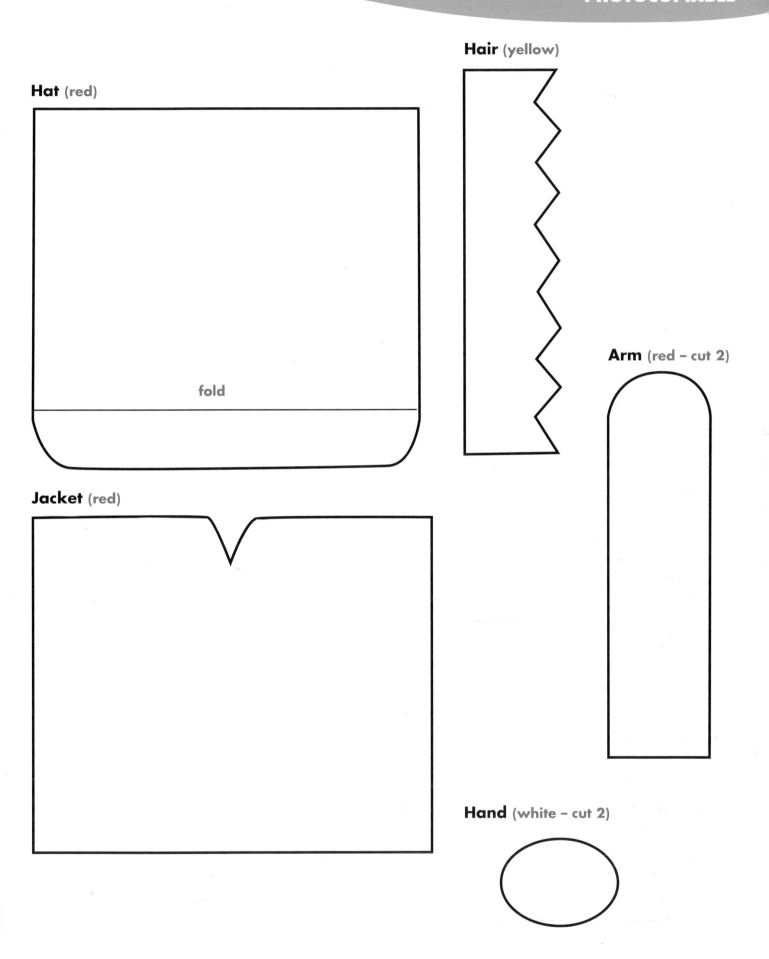

Hair (yellow)

Hat (red)

fold

Arm (red – cut 2)

Jacket (red)

Hand (white – cut 2)

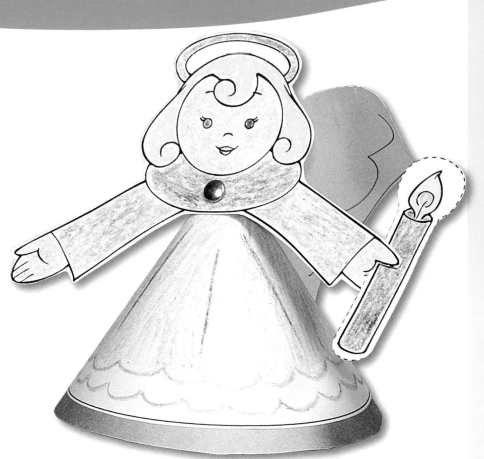

A Christmas angel

This easy-to-make angel has so many uses. It could be a tree ornament, a table decoration used as a display border or a gift to take home. Let the children trace round the templates and cut the parts out. Encourage them to design and colour in the angel's dress.

MATERIALS

- copies of photocopiable pages 41 and 42 for each child
- 20 cm square of pink card for the body
- 12.5 x 23 cm white card for the head and arms
- crayons, felt-tip pens or coloured pencils
- glue
- double-sided sticky tape
- scissors
- paper fastener
- hole punch
- length of ribbon or wool

STEPS TO FOLLOW

1. Colour in and cut out the patterns.

2. Glue the body pattern to the centre of the pink card. Trim around the edge, leaving a pink rim visible.

3. Glue the head and arms pattern to the white card. Trim around the outside edge close to the pattern.

4. Cut on the dotted line into the centre of the body pattern. Fold on the designated lines.

5. Place a strip of double-sided sticky tape along the fold line on the wings. Roll the body into a cone shape and let the tape stick the wings together. Roll the tips of the wings out.

6. Use a paper fastener to attach the head and arms to the body.

7. Use double-sided sticky tape to secure the candle in one hand.

8. Punch a hole in the back. Tie a ribbon through the hole to use as a hanger.

National Curriculum: Art & design
KS1: 2a, 2b, 4a, 4b, 5b, 5c
KS2: 2a, 2b, 4a, 4b, 5b, 5c
QCA Schemes: Art & design
Unit 1B – Investigating materials
Scottish 5-14 Guidelines: Art & design
Using materials, techniques, skills and media: Using media; Using visual elements
Expressing feelings, ideas, thoughts and solutions: Creating and designing; Communicating

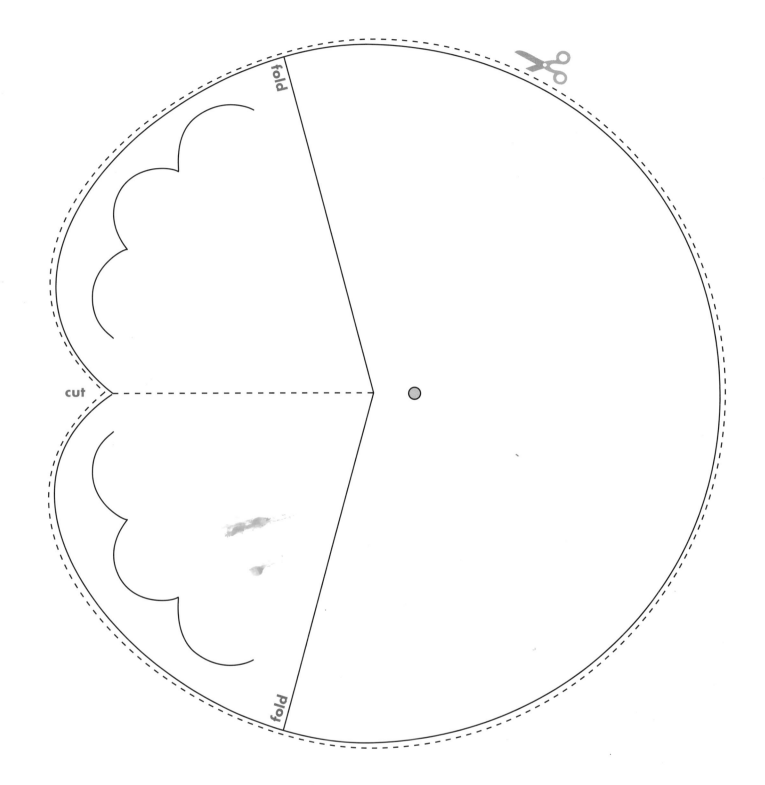

fold

cut

fold

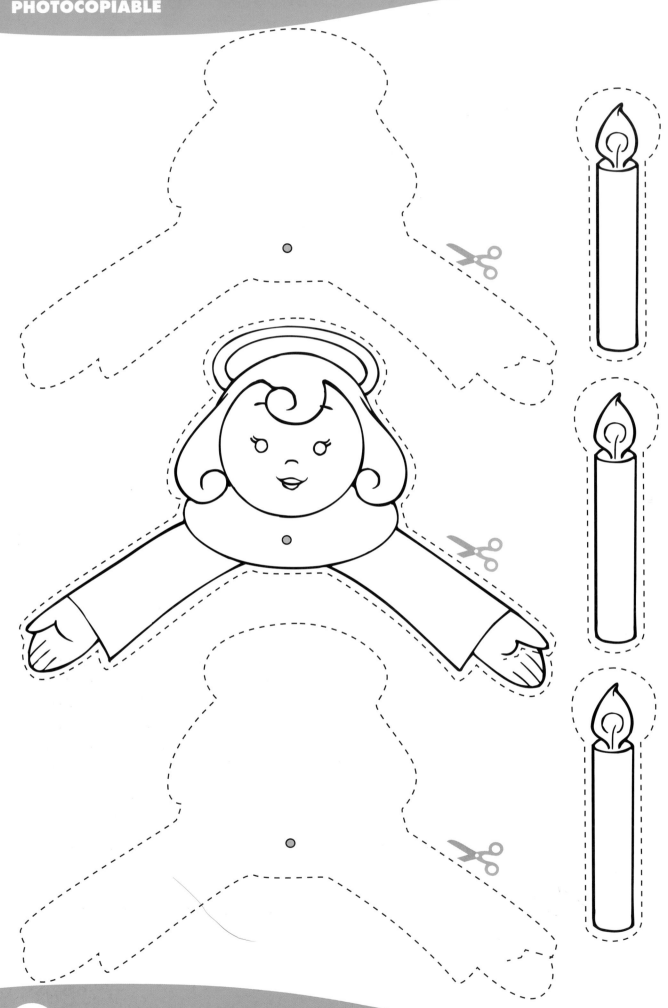

Creative Activities • Art for all Seasons • **www.scholastic.co.uk**

This three-dimensional model of a reindeer and its sleigh is very simple and quick to make. Children can learn how to make a simple paper figure by cutting it into shape. They may also want to add a driver and a big bag of toys to the sleigh.

MATERIALS

- 12.5 x 20 cm brown card for the reindeer
- 2.5 x 5 cm black card for the antlers
- 15 x 18 cm red card for the sleigh
- 2.5 x 15 cm black card for the runners
- 11.5 x 30.5 cm blue card for the base
- a strip of green wool or ribbon
- scraps of paper in assorted colours for details
- foil star stickers
- marker pen
- scissors
- glue

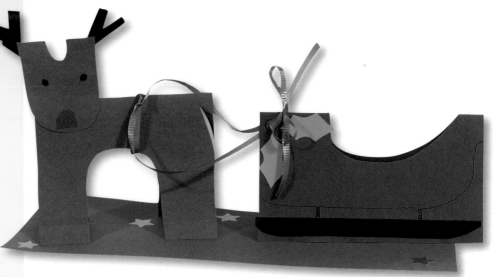

Sleigh time

STEPS TO FOLLOW

1. Fold the brown card in half. Sketch and cut out a hill shape for the reindeer's head as shown.

2. Cut strips from the black card for the antlers. Glue them to one of the head pieces.

3. Add eyes and a nose to both of the head pieces using a marker pen and scraps of paper.

4. Glue the two head pieces back to back around one end of the body. Cut a small tail on the opposite end of the reindeer. Also fold up 1 cm of each leg. Now the reindeer is ready to go.

5. Fold the red card in half for the sleigh. Cut out a part on the fold as shown. Trim the edges of the black runner paper and glue to the sleigh. Add other details with a marker pen and scraps of paper.

6. Stand the reindeer and the sleigh on the blue base to give the impression that they are soaring through the night sky. Add foil stars to the blue card.

7. Tie the reindeer and sleigh together with a green ribbon.

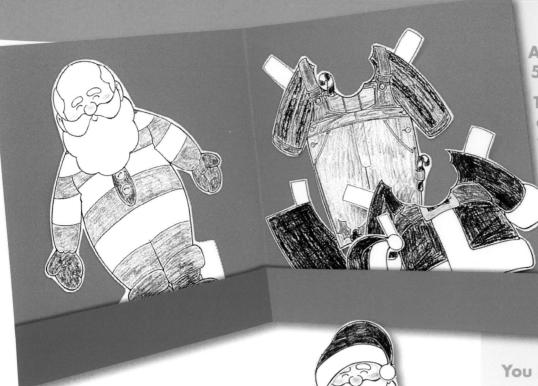

My Santa paper doll

STEPS TO FOLLOW

1. Colour in and cut out the Santa pattern.

2. Colour in an outfit for the jolly fellow using the patterns provided.

3. Cut out the clothing and try it on him.

4. Fold the green folder card in half and then fold up the bottom 5 cm. Glue the label provided to the front. Slip Santa and his outfits inside and tuck them away for a later time.

AGE RANGE:
5-7 years

This fun Santa paper doll can be used to inspire children to design a whole new wardrobe for Santa. As they design their own clothes, highlight the size and shape of the Santa figure. Older children might like to use textiles to clothe Santa. You might also want to encourage children to think about what Santa might wear at other times of the year.

MATERIALS

- copies of photocopiable pages 45–47 for each child

- 30.5 x 45.5 cm green card for the folder cover

- crayons, felt-tip pens or coloured pencils

- scissors

- glue

National Curriculum: Art & design
KS1: 2a, 2b, 2c, 4a, 4b, 5b, 5c
QCA Schemes: Art & design
Unit 1B – Investigating materials
Scottish 5-14 Guidelines: Art & design
Using materials, techniques, skills and media:
Investigating visually and recording;
Using media; Using visual elements
Expressing feelings, ideas, thoughts
and solutions: Creating and designing;
Communicating

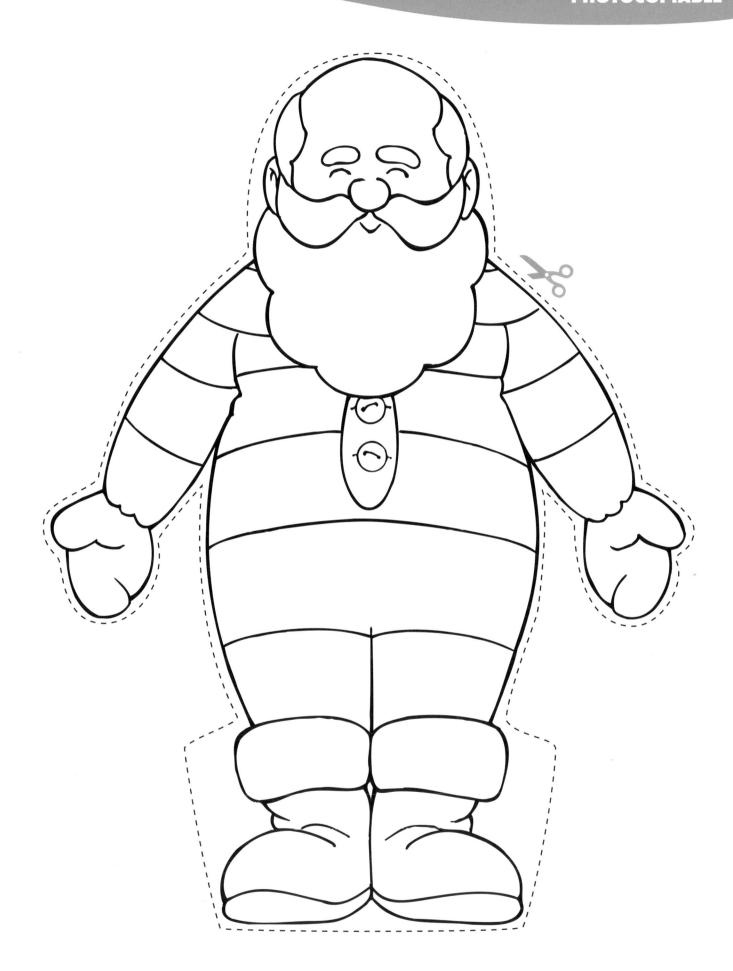

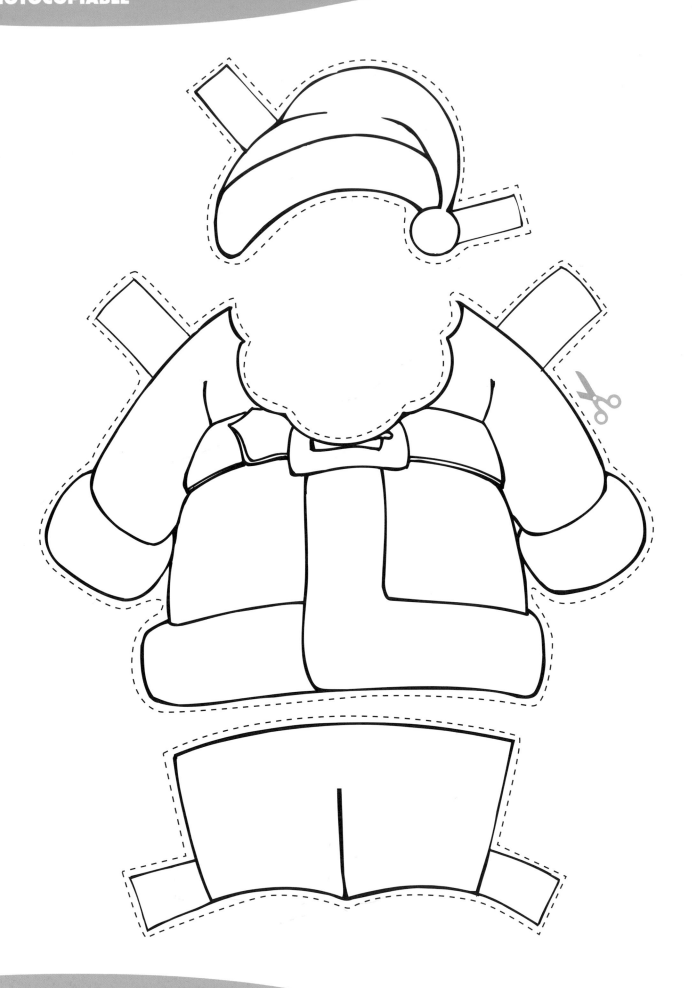

Folder label

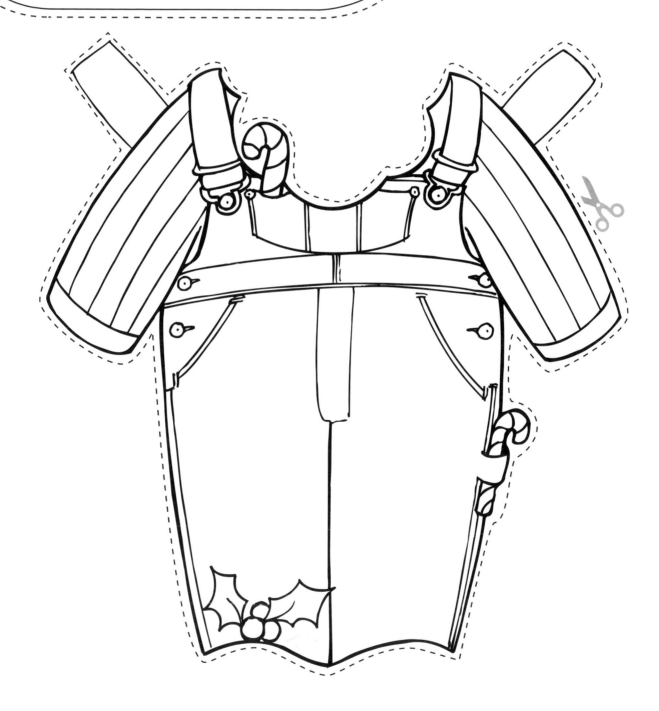

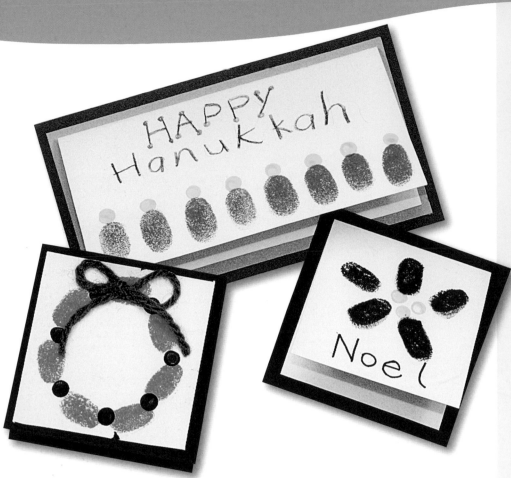

Children can print attractive festive card designs by just using their fingers and pencil rubbers. They can also use this technique on large sheets of paper to make their own unique wrapping paper.

MATERIALS

- thin white card cut to desired sizes for base of card
- coloured card cut to frame card
- red, green and blue ink pads
- crayons, felt-tip pens or coloured pencils
- red and yellow tempera paint
- pencil with a new rubber
- glue
- scissors
- wool or ribbon

Festive fingerprint art cards

STEPS TO FOLLOW

1. Experiment with using fingers as a print tool. Stamp designs on practice paper to experiment with how hard to press, etc.

2. Fold the card in half.

3. Create the fingerprint design on the front cover.

4. Use a pencil rubber dipped in tempera paint to add details.

5. Use the crayons, felt-tip pens or coloured pencils to add a greeting inside.

6. Glue the card onto complementary-coloured card to add colour.

7. Add wool as a finishing touch.

National Curriculum: Art & design
KS1: 2a, 2b, 2c, 4a, 4b, 5b, 5c
KS2: 2a, 2b, 2c, 4a, 4b, 5b, 5c
QCA Schemes: Art & design
Unit 1B – Investigating materials
Scottish 5-14 Guidelines: Art & design
Using materials, techniques, skills and media:
Investigating visually and recording; Using media; Using visual elements
Expressing feelings, ideas, thoughts and solutions: Creating and designing

These sugar cane decorations are very simple to make and can be used as small gifts or festive decorations. Encourage children to think of different ways they can decorate the white card before it is rolled up into a cane.

MATERIALS

- 20 cm square of white paper
- 18 cm square of white paper
- 15 cm square of white paper
- red crayon
- tape
- pencil
- ribbon

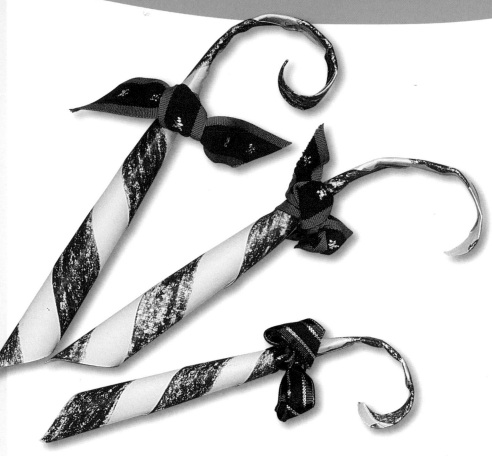

The most remarkable sugar cane

STEPS TO FOLLOW

1. Draw a red stripe along two outer edges of the white paper. Flip the paper over.

2. Beginning at the corner **opposite** the coloured edges, roll the paper around a pencil. Keep rolling until the paper is completely rolled up. The real fun is seeing the sugar-cane effect develop as you roll the paper.

3. Tape down the end point of the paper.

4. Flatten one end of the sugar cane. Now roll that over the pencil to create the hooked end.

5. Tie a ribbon around the sugar cane.

6. Repeat with the other squares of paper.

Flip the paper over.

National Curriculum: Art & design
KS1: 2a, 2b, 4a, 4b, 5b, 5c
KS2: 2a, 2b, 4a, 4b, 5b, 5c
QCA Schemes: Art & design
Unit 1B – Investigating materials
Scottish 5-14 Guidelines: Art & design
Using materials, techniques, skills and media: Using media; Using visual elements
Expressing feelings, ideas, thoughts and solutions: Creating and designing

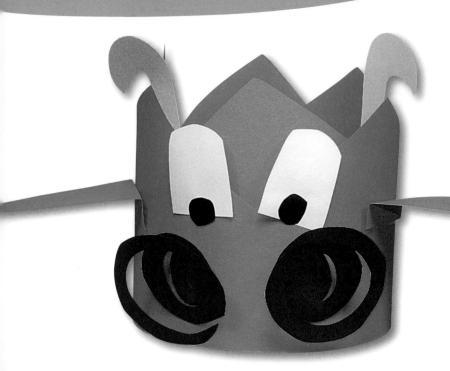

AGE RANGE: 5-7 years

Celebrate Chinese New Year by letting children make their own Chinese dragon headbands. The headband templates allow the children to develop careful cutting skills.

MATERIALS

- photocopiable page 51
- 25.5 x 45.5 cm green card for the headband
- two 5 x 12.5 cm pieces of green card for the ears
- two 4 x 5 cm pieces of white card for the eyes
- two 2.5 cm squares of black card for the pupils
- two 7.5 cm squares of red card for the nostrils
- two 6 x 7.5 cm pieces of yellow card for the horns
- pencil
- scissors
- glue

Chinese New Year dragon

STEPS TO FOLLOW

1. Sketch a zigzag line on the green headband card. Cut on that line.

2. Fit the headband strip to the child's head. Remove and staple the end in place. Let the left-over section stick out.

3. Stand the headband on a table and decide where the face of the dragon will best fit. Use the templates to help cut out the pieces.
 a. Round the corners on the white card for the eyes.
 b. Cut circles from the black pieces for the pupils.
 c. Cut ear shapes from the green card. Fold down a flap on the end.
 d. Cut spirals from the red card for nostrils.
 e. Cut horns from the yellow card.

4. Glue all the pieces in place.

National Curriculum: Art & design
KS1: 2a, 2b, 4a, 4b, 4c, 5b, 5c
QCA Schemes: Art & design
Unit 1B – Investigating materials
Scottish 5-14 Guidelines: Art & design
Using materials, techniques, skills and media: Using media; Using visual elements Expressing feelings, ideas, thoughts and solutions: Creating and designing

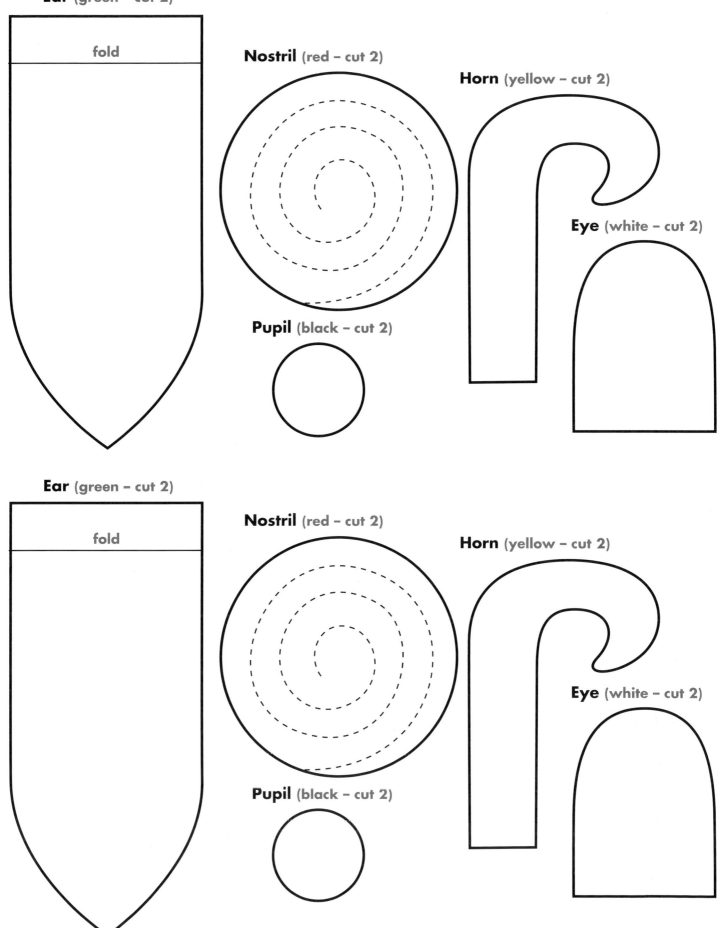

Ear (green – cut 2)

fold

Nostril (red – cut 2)

Horn (yellow – cut 2)

Eye (white – cut 2)

Pupil (black – cut 2)

Ear (green – cut 2)

fold

Nostril (red – cut 2)

Horn (yellow – cut 2)

Eye (white – cut 2)

Pupil (black – cut 2)

AGE RANGE: 5-11 years

These attractive Valentine cards help children develop basic weaving skills.

Encourage them to experiment with different colour variations and different thicknesses of paper.

A woven Valentine card

STEPS TO FOLLOW

1. Trace around the templates on the paper.
2. Cut the slits as indicated.
3. Fold the double piece on the fold line.
4. Weave the two sections together as shown.
5. Glue the end pieces to secure them.
6. Cut a small heart from scraps of paper. Glue it and the message inside the card.

MATERIALS

- photocopiable page 53
- 15 x 30.5 cm white or pink paper or thin card
- 10 x 15 cm red or purple paper or thin card
- scissors
- glue
- pencil

National Curriculum: Art & design
KS1: 2a, 2b, 4a, 4b, 5b, 5c
KS2: 2a, 2b, 4a, 4b, 5b, 5c
QCA Schemes: Art & design
Unit 1B – Investigating materials
Scottish 5-14 Guidelines: Art & design
Using materials, techniques, skills and media: Using media; Using visual elements
Expressing feelings, ideas, thoughts and solutions: Creating and designing

Message

Happy
Valentine's
Day

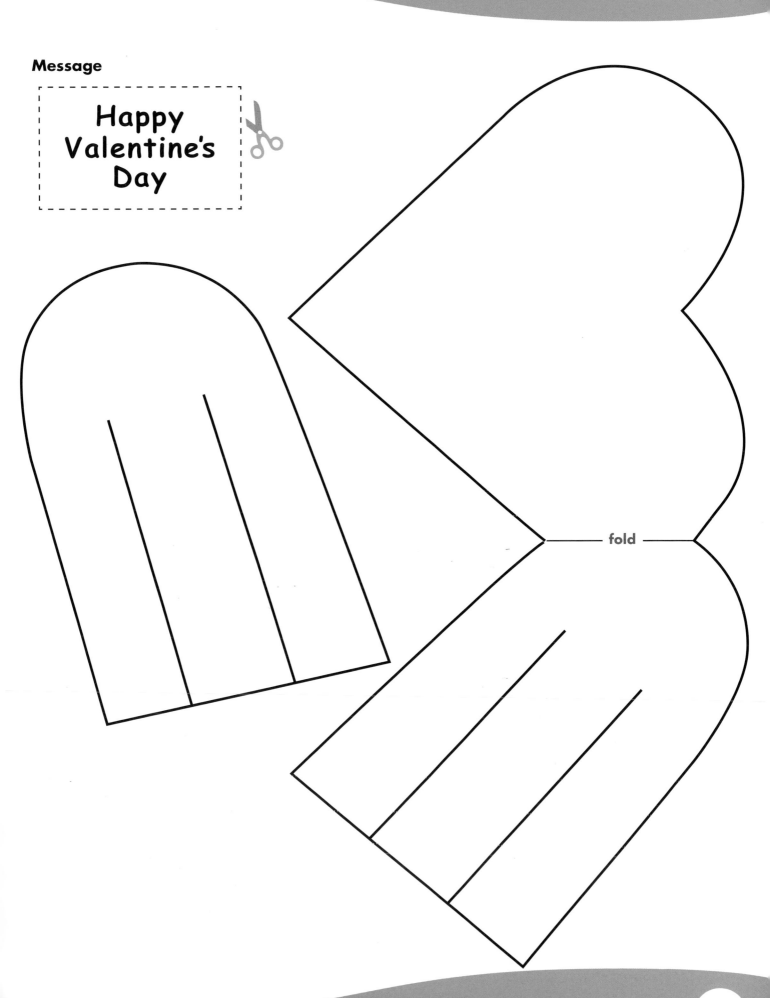

fold

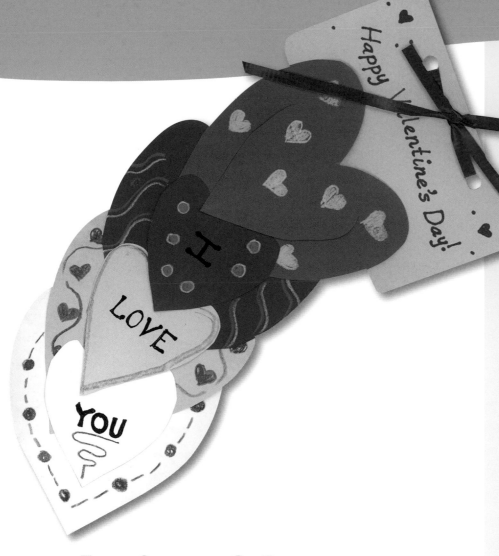

A chain of hearts

AGE RANGE: 5-11 years

This activity highlights ways of drawing and cutting out a simple symmetrical shape such as a heart. By cutting part of a smaller heart within a larger heart, children can make an attractive two-dimensional Valentine chain. The chain can go on and on with a simple message added within it.

MATERIALS

- photocopiable page 55
- 12.5 cm square of thin card or sugar paper for each heart in the chain
- 6 x 11 cm thin card for the top piece
- red ribbon
- hole punch
- scissors
- pencil
- crayons, felt-tip pens or coloured pencils
- glue

STEPS TO FOLLOW

1. Fold each square of card or sugar paper in half. Lay the outer heart template on the fold and trace a light pencil line around it. Cut on the line.

2. Place the inner heart on the fold. Repeat the process for each heart.

3. Open the hearts and decorate them with crayons, felt-tip pens or coloured pencils.

4. Interlock the hearts to form a chain.

5. Write a caption and decorate the top piece. Round the corners.

6. Glue the top of the first heart to the top piece.

7. Punch two holes in the top piece and insert the ribbon. Tie it in a bow.

National Curriculum: Art & design
KS1: 2a, 2b, 2c, 4a, 4b, 5b, 5c
KS2: 2a, 2b, 2c, 4a, 4b, 5b, 5c
QCA Schemes: Art & design
Unit 1B – Investigating materials
Scottish 5-14 Guidelines: Art & design
Using materials, techniques, skills and media: Using media; Using visual elements
Expressing feelings, ideas, thoughts and solutions: Creating and designing

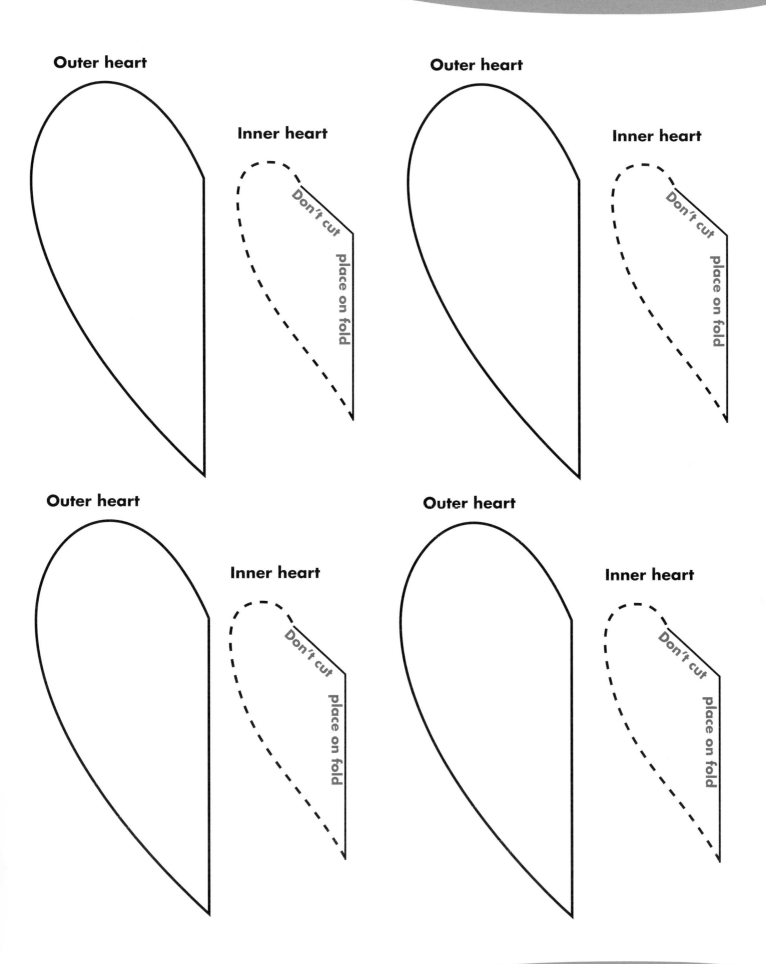

Outer heart

Inner heart

Don't cut

place on fold

Outer heart

Inner heart

Don't cut

place on fold

Outer heart

Inner heart

Don't cut

place on fold

Outer heart

Inner heart

Don't cut

place on fold

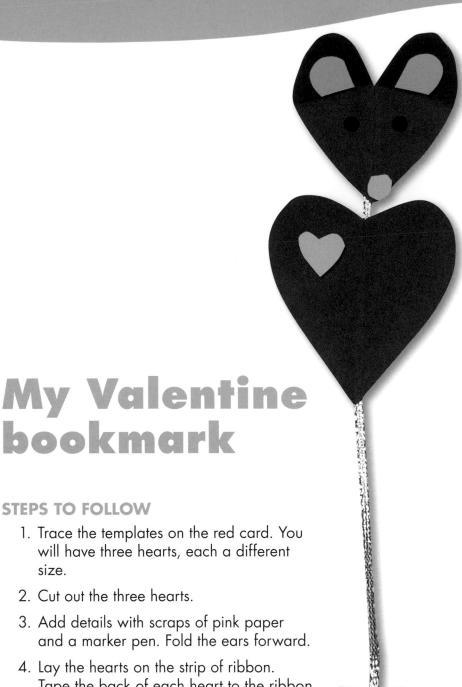

My Valentine bookmark

AGE RANGE: 5-7 years

These bookmarks can double as Valentine cards or gifts. Highlight how the main three Valentine hearts can be decorated in unusual ways to make the bookmark more unique.

MATERIALS

- photocopiable page 57
- 7.5 x 20 cm red card or paper for the hearts
- pink scraps of card or paper
- black marker pen
- 20 cm length of ribbon
- scissors
- tape
- pencil

STEPS TO FOLLOW

1. Trace the templates on the red card. You will have three hearts, each a different size.

2. Cut out the three hearts.

3. Add details with scraps of pink paper and a marker pen. Fold the ears forward.

4. Lay the hearts on the strip of ribbon. Tape the back of each heart to the ribbon.

5. Use the bookmark to save your place in your favourite storybook.

National Curriculum: Art & design
KS1: 2a, 2b, 2c, 4a, 4b, 5b, 5c
QCA Schemes: Art & design
Unit 1B – Investigating materials
Scottish 5-14 Guidelines: Art & design
Using materials, techniques, skills and media:
Using media; Using visual elements
Expressing feelings, ideas, thoughts and
solutions: Creating and designing

Body

Head

Tail

Body

Head

Tail

Body

Head

Tail

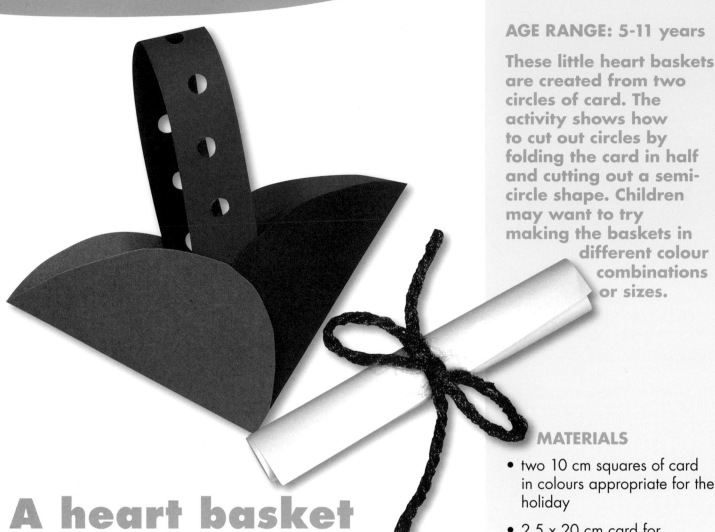

These little heart baskets are created from two circles of card. The activity shows how to cut out circles by folding the card in half and cutting out a semi-circle shape. Children may want to try making the baskets in different colour combinations or sizes.

A heart basket

STEPS TO FOLLOW

1. Fold the card squares in half. Round the corners.

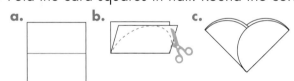

2. Place one folded circle inside the other to form a right angle. Glue them in that position to form the basket.

3. Punch holes to form a pattern on the handle.

4. Glue the handle to the basket.

5. Write a Valentine's message on the scroll paper. Roll it up and secure it with a piece of ribbon or yarn.

MATERIALS

• two 10 cm squares of card in colours appropriate for the holiday

• 2.5 x 20 cm card for the handle

• 10 cm square of white paper for the scroll

• hole punch

• scissors

• glue

• wool or ribbon

National Curriculum: Art & design
KS1: 2a, 2b, 4a, 4b, 5b, 5c
KS2: 2a, 2b, 4a, 4b, 5b, 5c
QCA Schemes: Art & design
Unit 1B – Investigating materials
Unit 5B – Containers
Scottish 5-14 Guidelines: Art & design
Using materials, techniques, skills and media:
Using media; Using visual elements
Expressing feelings, ideas, thoughts and
solutions: Creating and designing

Contents

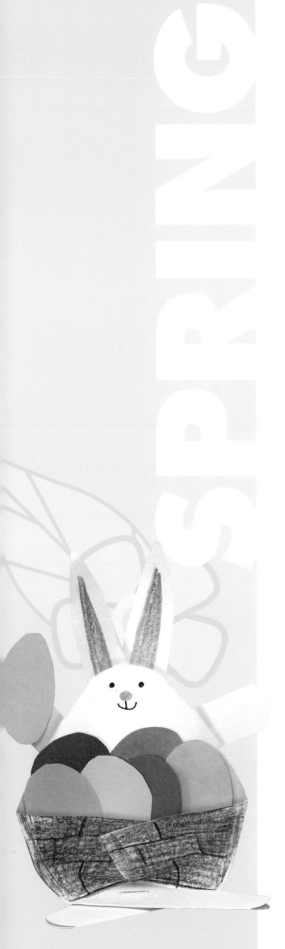

During the spring, flowers start to come out, the birds start to make nests, butterflies appear and the leaves on the trees start to come out. There is a lot to observe as nature seems to change almost weekly.

In this chapter there are art projects observing nature such as a finger-painted still life of geraniums. There are also models of minibeasts and frogs using a range of materials.

Easter is the biggest festival in spring. This chapter has a wide range of art projects for the Easter period including cards, decorations and gifts.

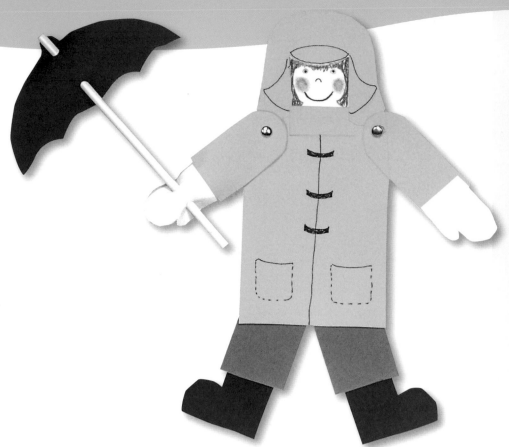

The anorak kids

This colourful cut-out figure has moveable arms. Younger children will find the big templates simple to cut out and easy to arrange into the right order. The figure can be used for displays or rainy day stories.

MATERIALS

- photocopiable pages 61and 62
- 15 x 30.5 cm yellow card for the anorak, arms, and hat
- 12.5 x 18 cm red card for the umbrella and boots
- two 5 x 6 cm pieces of blue card for the trouser legs
- 12.5 x 18 cm white card for the head and hands
- two paper fasteners
- drinking straw
- hole punch
- scissors
- glue
- crayons, felt-tip pens or coloured pencils

STEPS TO FOLLOW

1. Use the templates to cut out the body parts from card: yellow – anorak, arms, and hat; red – umbrella and boots; white – head and hands.

2. Lay all the parts on the table to see how they match up. Add the blue pieces for the trouser legs.

3. Punch holes as indicated on the anorak and arms.

4. Attach the arms to the main body of the anorak with the paper fasteners.

5. Glue the rest of the pieces together.

6. Create a handle for the umbrella by inserting the straw through the holes punched in the right hand and the umbrella.

7. Add details with crayons, felt-tip pens or coloured pencils.

National Curriculum: Art & design
KS1: 2a, 2b, 4a, 4b, 5b, 5c
KS2: 2a, 2b, 4a, 4b, 5b, 5c
QCA Schemes: Art & design
Unit 1A – Self portrait
Unit 1B – Investigating materials
Scottish 5-14 Guidelines: Art & design
Using Materials, techniques, skills and media:
Using media; Using visual elements
Expressing feelings, ideas, thoughts
and solutions: Creating and designing;
Communicating

Umbrella (red)

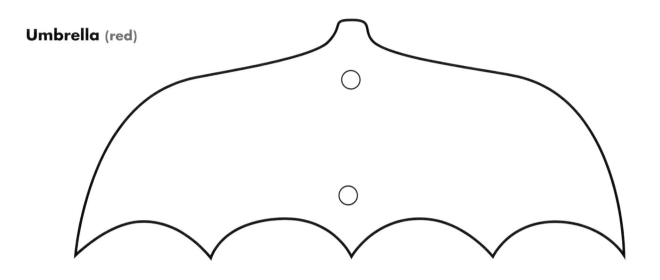

Anorak (yellow)

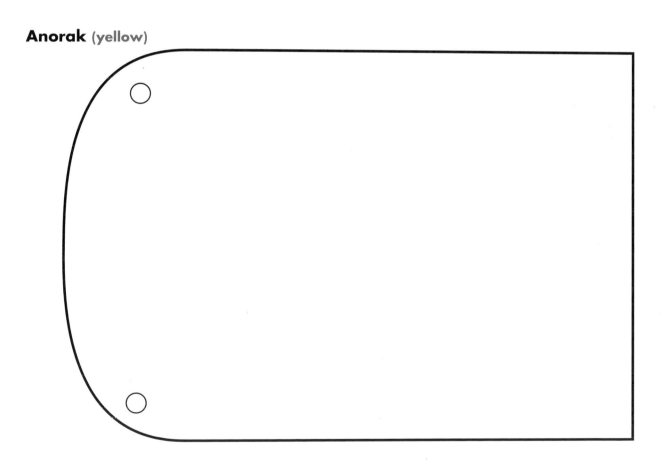

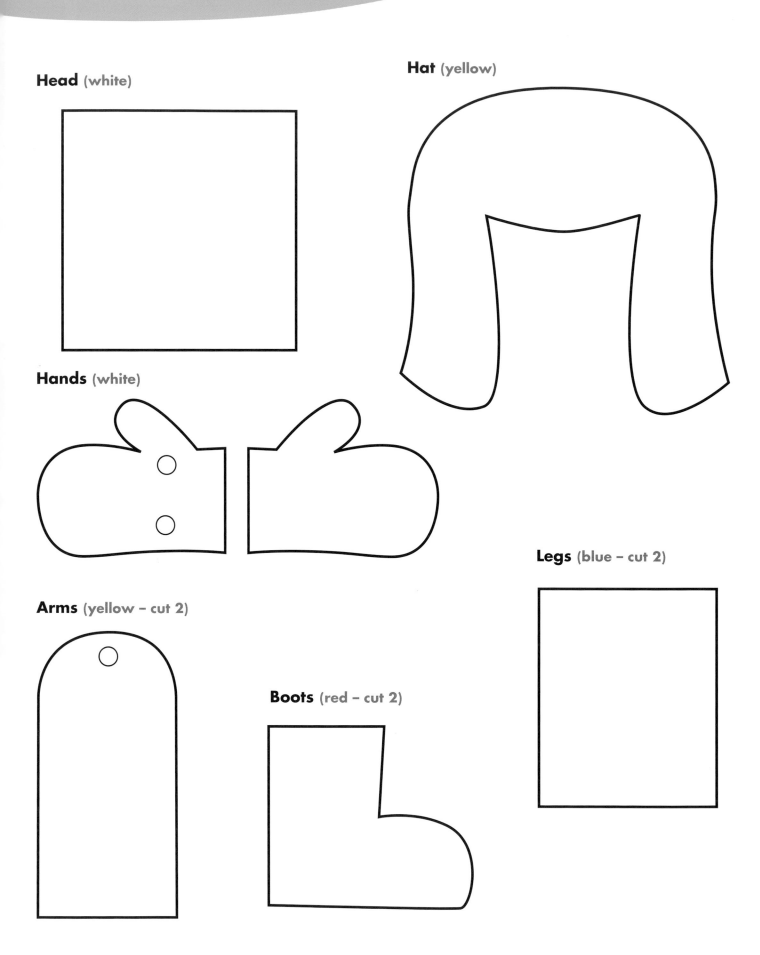

Head (white)

Hat (yellow)

Hands (white)

Legs (blue – cut 2)

Arms (yellow – cut 2)

Boots (red – cut 2)

AGE RANGE: 5-11 years

Just like a spring storm, this project is dramatic. It combines simple form, colour, texture and shape to convey stormy weather in a city. After they have made the pictures children could develop the same idea for another location.

MATERIALS

- 23 x 30.5 cm light blue sugar paper for the background
- 5 x 45.5 cm black sugar paper for the buildings
- 10 x 15 cm white and dark blue sugar paper for the clouds
- 5 x 30.5 cm yellow sugar paper for the lightning and window colour
- 24 x 31.5 cm black sugar paper for the frame
- blue tempera paint
- toothbrush
- glitter
- hole punch
- scissors
- glue

National Curriculum: Art & design
KS1: 2a, 2b, 4a, 4b, 5b, 5c
KS2: 2a, 2b, 4a, 4b, 5b, 5c
QCA Schemes: Art & design
Unit 1B – Investigating materials
Unit 2C – Can buildings speak?
Unit 6C – A sense of place
Scottish 5-14 Guidelines: Art & design
Using materials, techniques, skills and media:
Investigating visually and recording; Using media; Using visual elements
Expressing feelings, ideas, thoughts and solutions: Creating and designing; Communicating

Stormy weather

STEPS TO FOLLOW

1. Cut the black strip of paper into sections and lay it on the light blue paper to create the city skyline.

2. Punch holes in the black pieces to represent windows. Cut pieces of yellow paper to glue behind the black to illuminate some of the windows.

3. Glue the buildings in place.

4. Sketch a cloud shape on the white paper. Hold the white and the dark blue paper together as you cut out the drawn shape. Glue them both in place, allowing the blue to slip below the white.

5. Use the toothbrush dipped in blue tempera to flick splatters all over the paper. Hint: This process requires close supervision. Allow the paint to dry.

6. Sketch a streak of lightning on the yellow paper. Cut it out. Apply a strip of glue down the centre and dribble glitter onto it. Press lightly and then shake off the excess. Allow to dry.

7. Glue the lightning in the sky.

8. Frame the picture by glueing it to the black paper.

April showers bring May flowers.

April showers

STEPS TO FOLLOW

1. Use the template as a guide to lightly sketch a line to show the cloud area. Dab the sponges in the white paint and paint in that area. Allow to dry.

2. Use coloured pencils, crayons, or felt-tip pens to print 'April showers bring May flowers' along the bottom of the blue paper.

3. Fold the white paper squares as shown. Round the corners.

4. Now you have a raindrop shape. Open it up. The raindrop is transformed into a flower! Colour in the flower.

5. Make several raindrops that open into flowers and glue them in the blue area.

6. Glue the blue sheet to the orange frame.

AGE RANGE: 5-11 years

This paper collage illustrates the old saying – 'April showers bring May flowers'. Using simple origami techniques, children find out how to turn a square piece of paper into a raindrop shape and then a flower. This activity can be linked to science work on growing.

MATERIALS

- photocopiable page 65
- 23 x 30.5 cm dark blue card for the background
- 25.5 x 33 cm orange card for the frame
- several 7.5 cm square pieces of white paper for the raindrop/flowers
- sponges cut into 2.5 cm squares
- white tempera paint
- shallow dish
- scissors
- glue
- crayons, felt-tip pens,

National Curriculum: Art & design
KS1: 2a, 2b, 2c, 4a, 4b, 5b, 5c
KS2: 2a, 2b, 2c, 4a, 4b, 5b, 5c
QCA Schemes: Art & design
Unit 1B – Investigating materials
Unit 2B – Mother Nature, designer
Unit 3B – Investigating pattern
Scottish 5-14 Guidelines: Art & design
Using materials, techniques, skills and media: Using media; Using visual elements
Expressing feelings, ideas, thoughts and solutions: Creating and designing

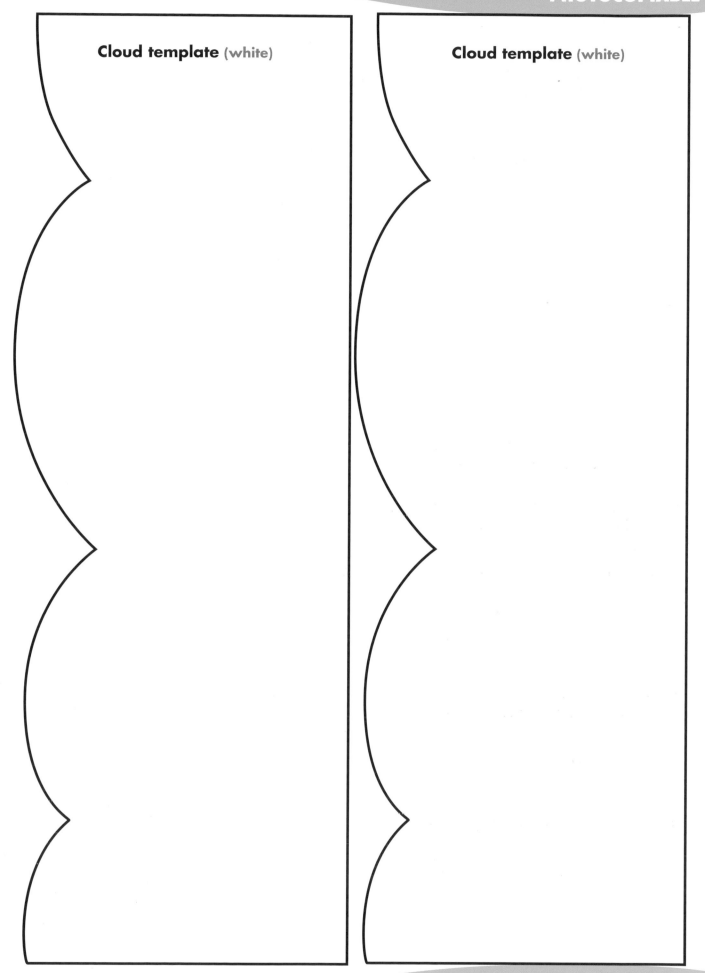

Cloud template (white)

Cloud template (white)

65

The butterfly flyer

STEPS TO FOLLOW

1. Use the templates to cut out the butterfly shapes from blue, yellow, and pink paper. Also cut two each of the large and small circles from each colour.

2. Lay out the three butterflies and position the spots so there are contrasting colours on each one as shown.

3. Punch two holes in each butterfly as marked on the templates.

4. Cut strips from the black paper for antennae. Fold in half and glue to the butterflies.

5. Thread the fishing line through the straw. Secure it at one end with tape.

6. Now thread the line through the first butterfly (on top) as shown. Tape the line on the back of the butterfly. Repeat this process for the other two butterflies. Tape the end of the fishing line to the back of the last butterfly.

AGE RANGE: 5-11 years

This activity shows children how to make an effective toy using butterfly shapes. The butterflies can be made in different colours and patterns. This activity could also be used for science topics.

MATERIALS

- photocopiable page 67

- 12.5 x 20 cm pieces of card in blue, yellow, and pink for the butterflies

- 7.5 cm squares of black card for the antennae

- drinking straw

- 0.9 m of clear plastic fishing line

- tape

- hole punch

- scissors

- glue

Thread string through holes. Tape the back.

Tape the line to the straw.

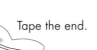

Tape the end.

National Curriculum: Art & design
KS1: 2a, 2b, 4a, 4b, 5b, 5c
KS2: 2a, 2b, 4a, 4b, 5b, 5c
QCA Schemes: Art & design
Unit 1B – Investigating materials
Unit 2B – Mother Nature, designer
Unit 3B – Investigating pattern
Scottish 5-14 Guidelines: Art & design
Using materials, techniques, skills and media:
Using media; Using visual elements
Expressing feelings, ideas, thoughts and
solutions: Creating and designing

Spots (blue, yellow, pink)

Butterflies (blue, yellow, pink)

Spots (blue, yellow, pink)

Butterflies (blue, yellow, pink)

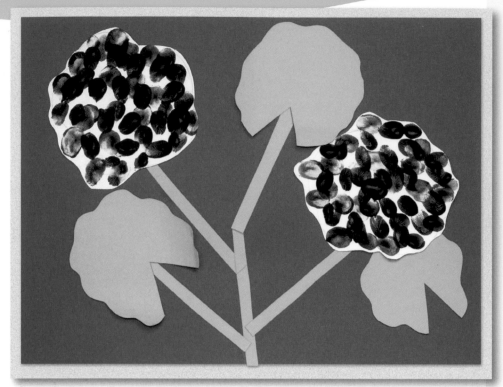

Fingerprint geraniums

STEPS TO FOLLOW

1. Trace around the flower template twice on the white card.

2. Dip a finger into the red paint. Fill the flower shapes with fingerprints. Cut out the flower shapes after the paint is dry.

3. Using the template as a guide, trace around and cut three leaves out of the green card.

4. Cut the last green square into narrow strips to use as stems.

5. Lay out the leaves and stems to establish a design. Glue in place.

6. Glue the blue paper to the yellow frame.

AGE RANGE: 5-11 years

This activity shows a method of recording first-hand observations of a flower. Bring pots of geraniums into the classroom to inspire the children before they start. Older children could cut parts of the flowers and leaves and make more detailed pictures.

MATERIALS

- photocopiable page 69

- 23 x 30.5 cm dark blue card for the background

- 24 x 31.5 cm yellow card for the frame

- 12.5 cm squares of white card for the geraniums

- 9 cm squares of green sugar paper or card for the leaves and stems

- red tempera paint

- pencil

- shallow dish

- glue

- scissors

National Curriculum: Art & design
KS1: 1a, 2a, 2b, 2c, 4a, 4b, 5b, 5c
KS2: 1a, 2a, 2b, 2c, 4a, 4b, 5b, 5c

QCA Schemes: Art & design
Unit 1B – Investigating materials
Unit 2B – Mother Nature, designer
Unit 5A – Objects and meanings

Scottish 5-14 Guidelines: Art & design
Using materials, techniques, skills and media:
Investigating visually and recording; Using media; Using visual elements
Expressing feelings, ideas, thoughts and solutions: Creating and designing; Communicating

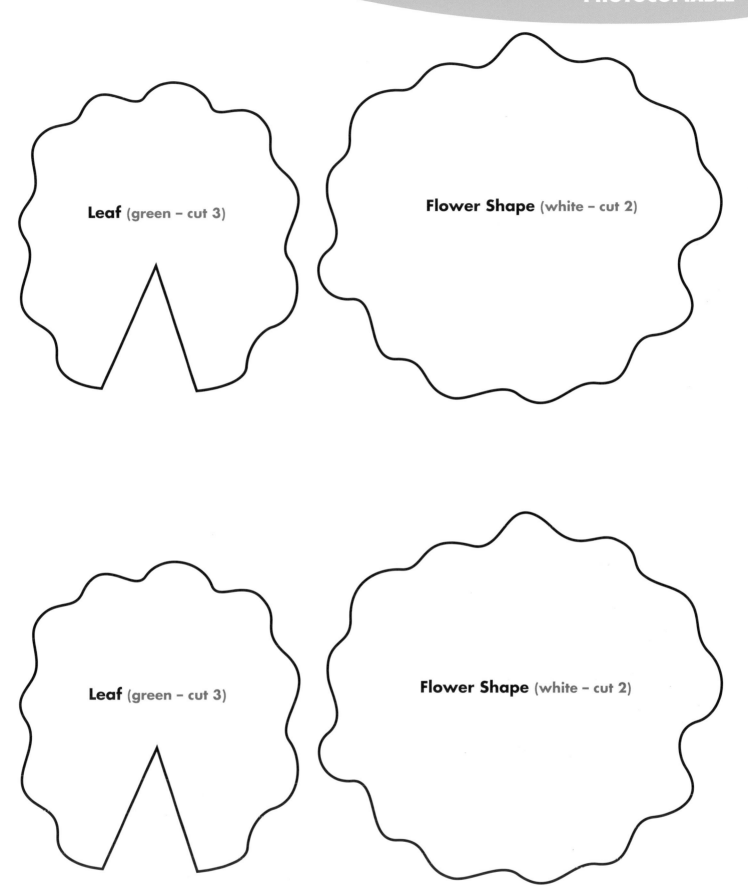

Leaf (green – cut 3)

Flower Shape (white – cut 2)

Leaf (green – cut 3)

Flower Shape (white – cut 2)

Birds bring a message of spring,
In every little song they sing.

Bird mobile

STEPS TO FOLLOW

1. Fold the blue and yellow card for the bodies as shown.

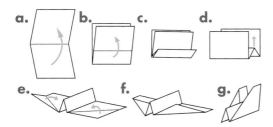

2. Trace around the template provided for the birds' heads on the blue and yellow squares. Cut them out and fold as indicated.

3. Draw beaks and eyes.

4. Glue the heads to the bodies.

5. Punch a hole in the centre of the back of each bird.

6. Tie one end of one length of fishing line through the hole punched in the yellow bird. Tie a knot. Thread the other end of the line through the straw and tie it through the hole punched in the blue bird.

7. Thread the other length of fishing line through the straw. Tie the two ends together. This forms a loop for hanging the mobile.

8. Fold the orange card in half. Lay it over the straw. Glue the paper shut to secure it around the straw.

9. Cut out and colour in the poem on the pattern page. Glue it to the orange card.

10. The mobile is now ready to hang.

AGE RANGE: 5-11 years

The birds in this mobile are made from a paper folding technique called origami. You could either show children the diagrams of how to fold the paper or demonstrate the technique to them. Hang the mobiles around the classroom.

MATERIALS

- photocopiable page 71
- 10 x 21.5 cm pieces of yellow and blue card for the birds' bodies
- 7.5 cm squares of the same yellow and blue card for the birds' heads
- 15 x 19 cm orange card
- plastic drinking straw
- two 76 cm lengths of clear plastic fishing line
- hole punch
- pencil
- scissors
- glue
- crayons, felt-tip pens or coloured pencils

National Curriculum: Art & design
KS1: 2a, 2b, 2c, 4a, 4b, 5b, 5c
KS2: 2a, 2b, 2c, 4a, 4b, 5b, 5c
QCA Schemes: Art & design
Unit 1B – Investigating materials
Scottish 5-14 Guidelines: Art & design
Using materials, techniques, skills and media:
Using media; Using visual elements
Expressing feelings, ideas, thoughts and
solutions: Creating and designing

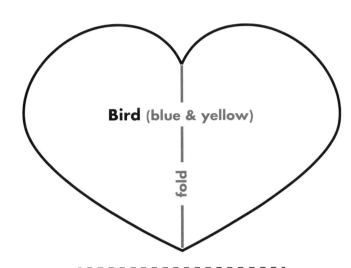

Bird (blue & yellow)

fold

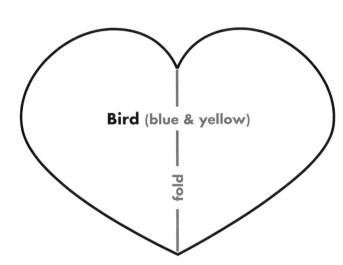

Bird (blue & yellow)

fold

Birds bring a message of spring,

In every little song they sing.

Birds bring a message of spring,

In every little song they sing.

In like a lion, out like a lamb

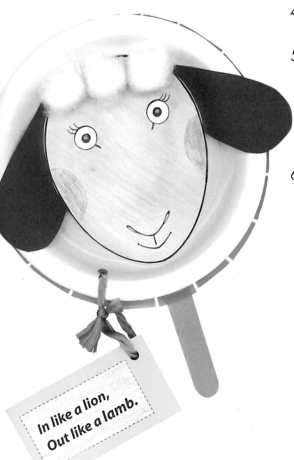

STEPS TO FOLLOW

1. Colour in and cut out the patterns.

2. Fringe the outside edge of the yellow plate. Glue the lion's head in the centre.

3. Glue the lamb's head in the centre of the white plate. Add the ears and cotton wool balls.

4. Glue the two cards to the yellow card.

5. Punch a hole in the edge of the white plate and the corner of the yellow paper. Insert the wool through both. Tie the ends together.

6. Tape the craft stick to the back of the yellow plate. Glue the back of the white plate to the back of the yellow plate. Allow the glue to dry.

*In like a lion,
Out like a lamb.*

March

AGE RANGE: 5-11 years

This 'flip-around' puppet illustrates the old weather saying about the month of March – 'In like a lion, out like a lamb'. Children may want to extend the flip-around puppet by using other old saying. The puppets could be used as a literacy or drama activity.

MATERIALS

- photocopiable page 73
- two 18 cm paper plates, one yellow and one white
- 6 x 10 cm yellow card for the label
- cotton wool balls
- craft stick
- wool or string
- hole punch
- scissors
- tape
- glue
- crayons, felt-tip pens or coloured pencils

National Curriculum: Art & design
KS1: 2a, 2b, 2c, 4a, 4b, 5b, 5c
KS2: 2a, 2b, 2c, 4a, 4b, 5b, 5c

QCA Schemes of Work: Art and design
Unit 1B – Investigating materials
Unit 2B – Mother Nature, designer

Scottish 5-14 Guidelines: Art & design
Using materials, techniques, skills and media:
Using media; Using visual element
Expressing feelings, ideas, thoughts and solutions: Creating and designing

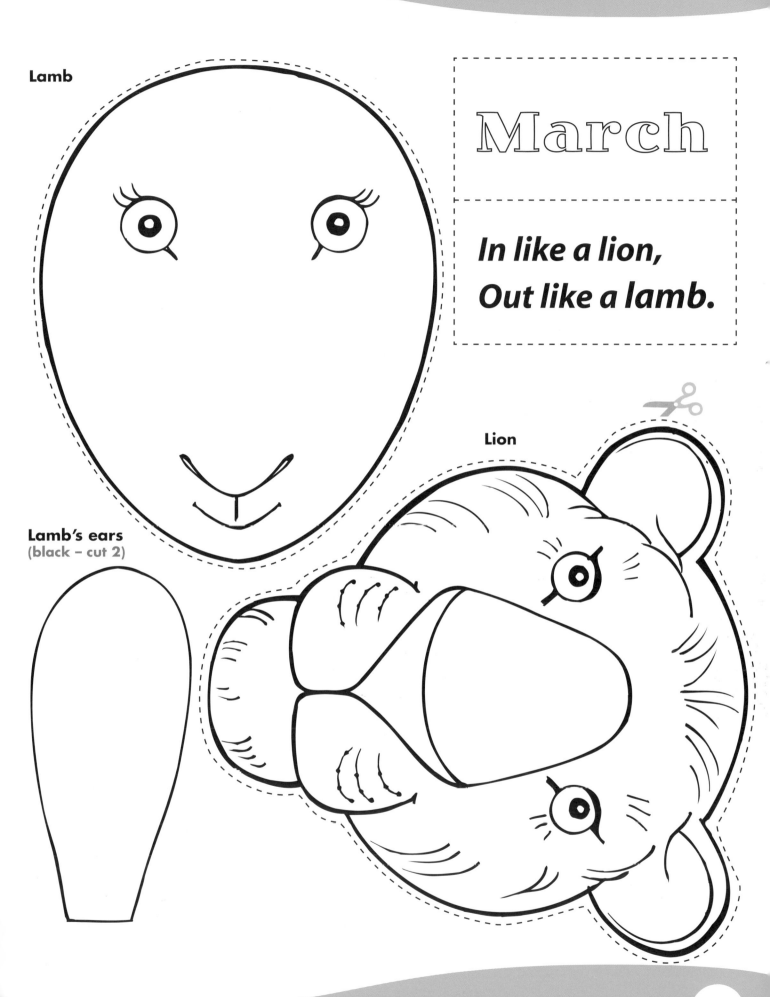

Lamb

March

In like a lion,
Out like a lamb.

Lamb's ears
(black – cut 2)

Lion

Watch my flower grow

STEPS TO FOLLOW

1. Colour in the pattern. Add a colourful background.

2. Cut the slit as marked. You may reinforce the slit edges with tape in case of heavy use.

3. Fold the paper in half.

4. Cut circles from the blue and yellow squares. Glue the yellow circle in the centre of the blue one. Fringe around the outside edge of the blue circle.

5. Cut two leaves from the green paper.

6. Use the red square to make a ladybird. Glue the ladybird to the flower.

7. Glue the flower and the leaves to the end of the craft stick. Slip the other end of the craft stick through the slit.

8. Glue the backside of the pattern to the green frame and watch the flower grow.

AGE RANGE: 5-11 years

By reaching inside the folder and pushing up the craft stick the flowers can be made to 'grow'. This moving art picture could be used alongside a science project on plants and growing things.

MATERIALS

- a copy of photocopiable page 75 for each child

- 7.5 cm square of blue sugar paper or card for the flower

- 4 cm square of yellow sugar paper or card for the flower centre

- 4 x 5 cm green sugar paper or card for the leaves

- 2.5 cm square of red card for the ladybird

- 15 x 21.5 cm green sugar paper or card for the frame

- craft knife

- crayons, felt-tip pens or coloured pencils

- craft stick

- scissors

- glue

- tape (optional)

National Curriculum: Art & design
KS1: 2a, 2b, 2c, 4a, 4b, 5b, 5c
KS2: 2a, 2b, 2c, 4a, 4b, 5b, 5c
QCA Schemes: Art & design
Unit 1B – Investigating materials
Unit 2B – Mother Nature, designer
Scottish 5-14 Guidelines: Art & design
Using materials, techniques, skills and media:
Investigating visually and recording; Using media; Using visual elements
Expressing feelings, ideas, thoughts and solutions: Creating and designing

Creative Activities • Art for all Seasons • **www.scholastic.co.uk**

slit

fold

Tissue paper banner

STEPS TO FOLLOW

1. Trace around the templates for the flower shape on one of the larger tissue paper squares. Place all the larger tissue squares together and cut out the shape.

2. Trace the flower centre on one of the smaller squares of tissue. Place them all together and cut them out.

3. Pull the backing off one of the contact strips. Lay it sticky side up on the table. Lay the flowers and their centres overlapping slightly on the contact paper.

4. Position the cellophane strips along the bottom of the banner.

5. Pull the backing off the second contact strip. Now ask a friend to help you lay the contact paper over the top of the tissue flowers. Press to seal the two pieces of contact paper together.

6. Fold the orange card in half. Glue the 'Hooray! It's Spring!' sign to one side.

7. Use double-sided sticky tape to secure the folded card to the top of the banner.

8. Punch two holes in the orange headpiece. Tie wool through each one to create the hanger strip.

AGE RANGE: 5-11 years

These bright and colourful tissue-paper banners can be hung around the school or classroom as a welcome to spring. The banner is made up of several materials including tissue paper, laminate and strips of cellophane.

MATERIALS

- photocopiable page 77
- six 2.5 cm squares of tissue in bright colours for the flowers
- six 5 cm squares of tissue in the same colours for the flower centres
- two 25.5 x 45.5 cm strips of clear contact paper or laminate
- 15 x 25.5 cm orange card for the headpiece
- wool
- 2.5 x 30.5 cm strips of cellophane
- hole punch
- scissors
- double-sided sticky tape
- glue

National Curriculum: Art & design
KS1: 2a, 2b, 2c, 4a, 4b, 5b, 5c
KS2: 2a, 2b, 2c, 4a, 4b, 5b, 5c
QCA Schemes: Art & design
Unit 1B – Investigating materials
Scottish 5-14 Guidelines: Art & design
Using materials, techniques, skills and media: Using media; Using visual elements
Expressing feelings, ideas, thoughts and solutions: Creating and designing

Sign pattern

Flower

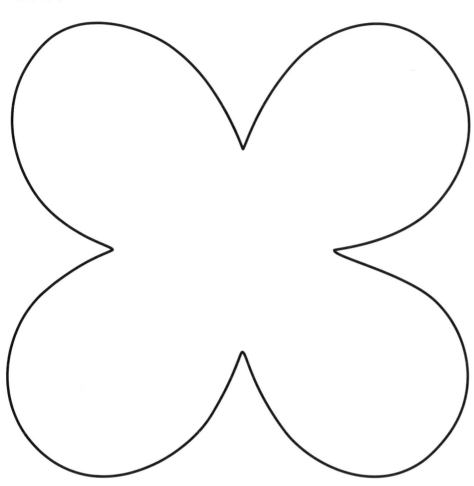

Flower centre

Delightful ducklings

STEPS TO FOLLOW

1. Trace around the templates on the yellow and orange card. Cut on the lines.

2. Fold the circles for the body and the wings in half.

3. Cut the wing circle on the fold line so there are now two half circles.

4. Fold the beak piece in half. Glue it to the head. Add eyes with crayons, felt-tip pens or coloured pencils.

5. Glue the head and wings to the body. Experiment with positions to create different effects.

6. Fold the feet piece in half and trim at an angle.

7. Glue the body to the feet.

AGE RANGE: 5-7 years

These easy-to-make ducklings can be used as part of a display or part of a literacy project. Encourage the children to experiment with the ducklings by putting their heads, beaks and wings in different positions. They can also be linked to science work on animals and their young.

MATERIALS

- photocopiable page 79
- 15 x 23 cm yellow card for the body, head, and wings
- 9 cm square of orange card for the feet and beak
- scissors
- glue
- crayons, felt-tip pens or coloured pencils

National Curriculum: Art & design
KS1: 2a, 2b, 2c, 4a, 4b, 5b, 5c
KS2: 2a, 2b, 2c, 4a, 4b, 5b, 5c

QCA Schemes: Art & design
Unit 1B – Investigating materials
Unit 2B – Mother Nature, designer

Scottish 5-14 Guidelines: Art & design
Using materials, techniques, skills and media:
Using media; Using visual elements
Expressing feelings, ideas, thoughts and solutions: Creating and designing

Body (yellow)

Head/Wings (yellow – cut 2)

Beak (orange)

Feet (orange)

Body (yellow)

Head/Wings (yellow – cut 2)

Beak (orange)

Feet (orange)

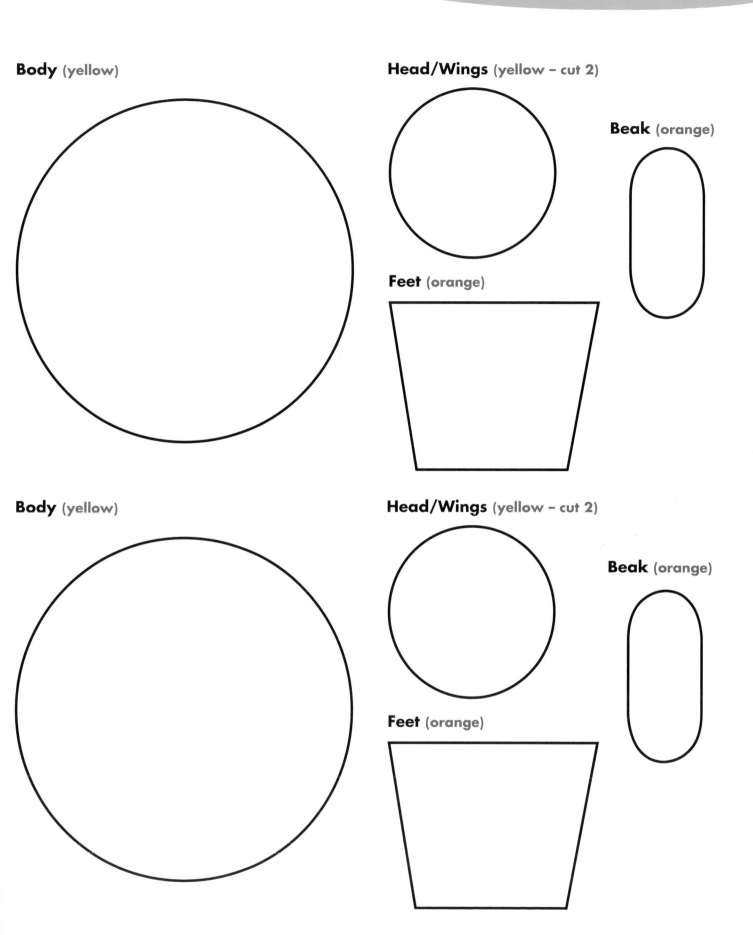

A colourful windsock

STEPS TO FOLLOW

1. Sketch a wavy line on the yellow card strip as shown. Cut on the line.
2. Glue the yellow strip to the top edge of the orange card.
3. Cut circles of varying sizes from the yellow, blue and pink card. Glue them in a random fashion onto the orange card.
4. Flip over the orange card. Glue the tissue strips evenly spaced along the bottom edge.
5. Roll the orange card into a cylinder and staple. Secure the rest of the opening with tape.
6. Punch two holes opposite each other on the yellow perimeter. Tie a piece of string through each hole. Tie the opposite ends together.
7. Tape the ends of the strings to the craft stick, which acts as a handle.

AGE RANGE: 5-11 years

This windsock is very simple for children to make. The main body of the windsock is a cylinder which is decorated with circles. The windsock is a good springboard for a discussion about the effect of forces.

MATERIALS

- 30.5 x 38 cm orange card for the base
- 10 x 45.5 cm yellow card for the cuff
- 15 cm squares of pink, yellow and blue card for decoration
- ten 2.5 x 23 cm strips of tissue paper
- craft stick
- string
- tape
- stapler
- hole punch
- scissors
- glue

National Curriculum: Art & design
KS1: 2a, 2b, 2c, 4a, 4b, 5b, 5c
KS2: 2a, 2b, 2c, 4a, 4b, 5b, 5c
QCA Schemes: Art & design
Unit 1B – Investigating materials
Unit 3B – Investigating pattern
Scottish 5-14 Guidelines: Art & design
Using materials, techniques, skills and media:
Using media; Using visual elements
Expressing feelings, ideas, thoughts and solutions: Creating and designing

This minibeast art activity uses three-dimensional paper construction, including folding and rolling. Encourage the children to think of different types of paper flowers they could add to the model as well as other creatures that may be found in the same environment.

MATERIALS

- 12.5 x 45.5 cm green card for the grass

- 2 x 15 cm yellow card strip for the worm

- several 5 cm squares of white paper for the wildflowers

- scraps of paper in assorted colours for the flower centres and leaves

- pencil

- scissors

- glue

- crayons, felt-tip pens or coloured pencils

National Curriculum: Art & design
KS1: 2a, 2b, 2c, 4a, 4b, 5b, 5c
KS2: 2a, 2b, 2c, 4a, 4b, 5b, 5c
QCA Schemes: Art & design
Unit 1B – Investigating materials
Unit 2B – Mother Nature, designer
Scottish 5-14 Guidelines: Art & design
Using materials, techniques, skills and media:
Investigating visually and recording; Using
media; Using visual elements
Expressing feelings, ideas, thoughts
and solutions: Creating and designing;
Communicating

Spring surprises

STEPS TO FOLLOW

1. Fold the green paper into quarters as shown. Sketch a zigzag line on one open end. Cut on that line.

a. b. c.

2. Open the green accordion-folded paper. It looks like a grassy strip. Plan how many flowers you will add. Each flower is made by rolling the paper into a cone over your finger and glueing it.

3. The centre of each flower is made by rolling a narrow strip of card around a pencil and then glueing one end inside the flower. Leaves may also be cut from scraps.

4. Glue the completed flowers and leaves to the grassy strip.

5. Add stems with crayons, felt-tip pens or coloured pencils.

6. Round the corners on the yellow strip for the worm. Add details with coloured pencils. Stand up the accordion-folded project and wind the worm through the blades of grass.

A chain of eggs card

STEPS TO FOLLOW

1. Colour in the patterns using the side of a crayon.

2. Cut out the patterns. Fold on the fold line and cut the inner line.

3. Lift the flap of the blue egg and slip it through the hole of the red egg.
Then lift the flap of the yellow egg and slip it through the hole of the blue egg. Now you have a chain of eggs.

4. Lay the eggs on the blue paper. Punch two holes as indicated on the egg pattern. Insert the wool and tie a bow.

5. Glue the grass and Happy Easter greeting onto the bottom of the blue card.

AGE RANGE: 5-7 years

This project makes an unusual Easter card. Through the use of careful cutting skills the eggs are connected to make a chain. The finished chains could be connected to make a decorative border.

MATERIALS

- a copy of photocopiable page 83 for each child
- 11 x 24 cm blue card for the background
- yellow string or wool
- crayons
- scissors
- hole punch
- glue

National Curriculum: Art & design
KS1: 2a, 2b, 2c, 4a, 4b, 5b, 5c
QCA Schemes: Art & design
Unit 1B – Investigating materials
Scottish 5-14 Guidelines: Art & design
Using materials, techniques, skills and media:
Using media; Using visual elements
Expressing feelings, ideas, thoughts and solutions: Creating and designing

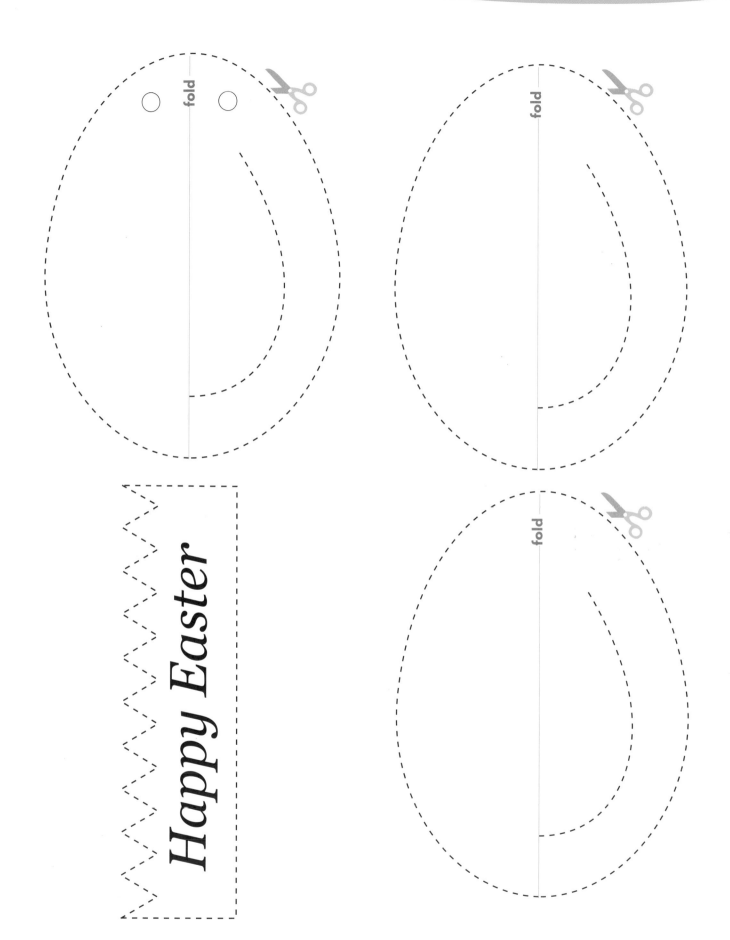

Happy Easter

fold

fold

fold

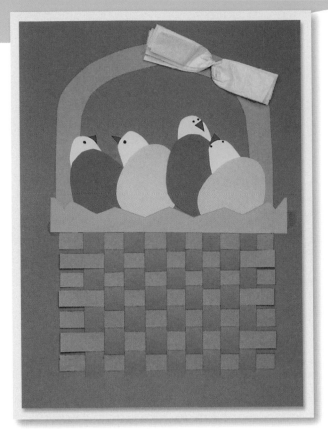

A basket full of fun

STEPS TO FOLLOW

1. Use the craft knife to make ten 12.5 cm vertical slits in the blue paper as shown.

2. Weave the seven orange strips into the slits. Push the strips to the bottom and glue the edges. There will be room to add more strips, but it is only there to make it easier to do the weaving. That area will be covered up by the eggs and grass.

12.5 cm

3. Fold the orange card for the handle. Place the template on the fold and trace around it. Cut on the lines and glue in place on the basket.

4. Cut out the grass, eggs, and chicks using the templates as a guide. Lay them on the blue card.

5. Glue all the parts in place. Notice that the chicks need to be under the eggs, and the eggs go under the grass.

6. Use the scraps of orange card for beaks and a black marker pen to add eyes to the chicks.

7. Fold the pink tissue paper like an accordion. Twist it in the middle and glue it to the handle of the basket.

8. Glue the blue card to the yellow card frame.

AGE RANGE: 5-11 years

This art project allows children to develop skills in paper weaving. The final effect is a mix of interesting textures.

MATERIALS

- photocopiable page 85
- 23 x 30.5 cm dark blue card for the background
- 24 x 32 cm yellow card for the frame
- seven 1.25 x 16.5 cm orange card strips for the basket
- 16.5 x 18 cm orange card for the handle
- 2.5 x 18 cm green card for the grass
- four 7.5 cm squares of pink and purple card for the eggs (two each)
- four 4 cm squares of yellow card for the chicks
- orange scraps for the beaks
- 10 x 15 cm pink tissue paper for the bow
- craft knife
- black marker pen
- glue
- scissors

National Curriculum: Art & design
KS1: 2a, 2b, 2c, 4a, 4b, 5b, 5c
KS2: 2a, 2b, 2c, 4a, 4b, 5b, 5c
QCA Schemes: Art & design
Unit 1B – Investigating materials
Unit 2B – Mother Nature, designer
Scottish 5-14 Guidelines: Art & design
Using materials, techniques, skills and media:
Using media; Using visual elements
Expressing feelings, ideas, thoughts and solutions: Creating and designing

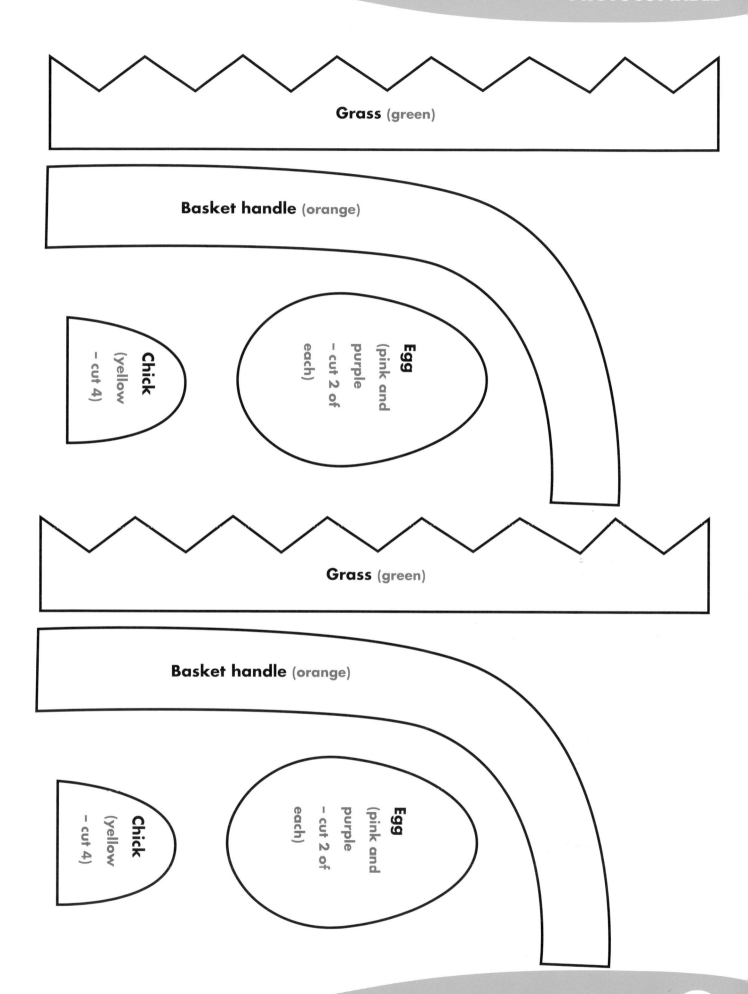

Grass (green)

Basket handle (orange)

Chick (yellow – cut 4)

Egg (pink and purple – cut 2 of each)

Grass (green)

Basket handle (orange)

Chick (yellow – cut 4)

Egg (pink and purple – cut 2 of each)

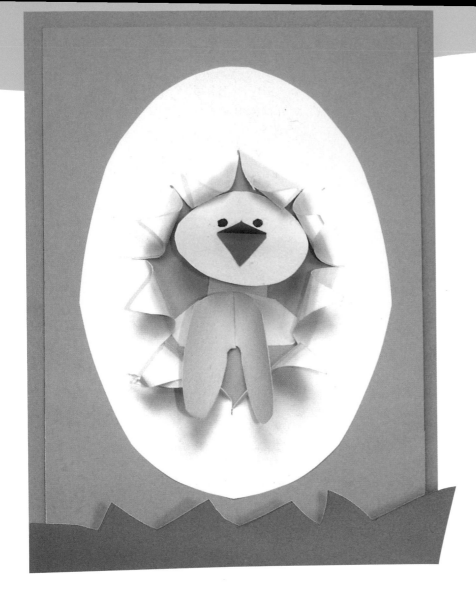

AGE RANGE: 5-11 years

This Easter card is unusual and effective because of its three-dimensional construction. By using paper folds on the different parts of the chick it can be made to look like it is coming out of the egg. This activity links well to science work on animals and their young.

MATERIALS

- a copy of photocopiable page 87 for each child

 Hint: These patterns may be used as templates if you want to create the project with card instead of paper.

- 12.5 x 18 cm light blue card for the backing

- 14 x 24 cm green card for the frame and grass

- scissors

- pencil

- glue

- black marker pen

Watch it hatch

STEPS TO FOLLOW

1. Colour in and cut out the patterns. Cut the inside lines on the egg. Curl each section back using a pencil.

2. Glue the egg to the blue card.

3. Follow the folding directions for the parts of the chick. Add the orange beak and black eyes. Glue the head to the neck. Glue the other end of the neck inside the egg opening. Glue the two wings below the head.

4. Cut a zigzag line on the bottom end of the green card.

5. Glue the blue card to the green card. Fold up the zigzagged bottom over the blue card.

National Curriculum: Art & design
KS1: 2a, 2b, 2c, 4a, 4b, 5b, 5c
KS2: 2a, 2b, 2c, 4a, 4b, 5b, 5c

QCA Schemes: Art & design
Unit 1B – Investigating materials
Unit 2B – Mother Nature, designer

Scottish 5-14 Guidelines: Art & design
Using materials, techniques, skills and media:
Using media; Using visual elements
Expressing feelings, ideas, thoughts and
solutions: Creating and designing

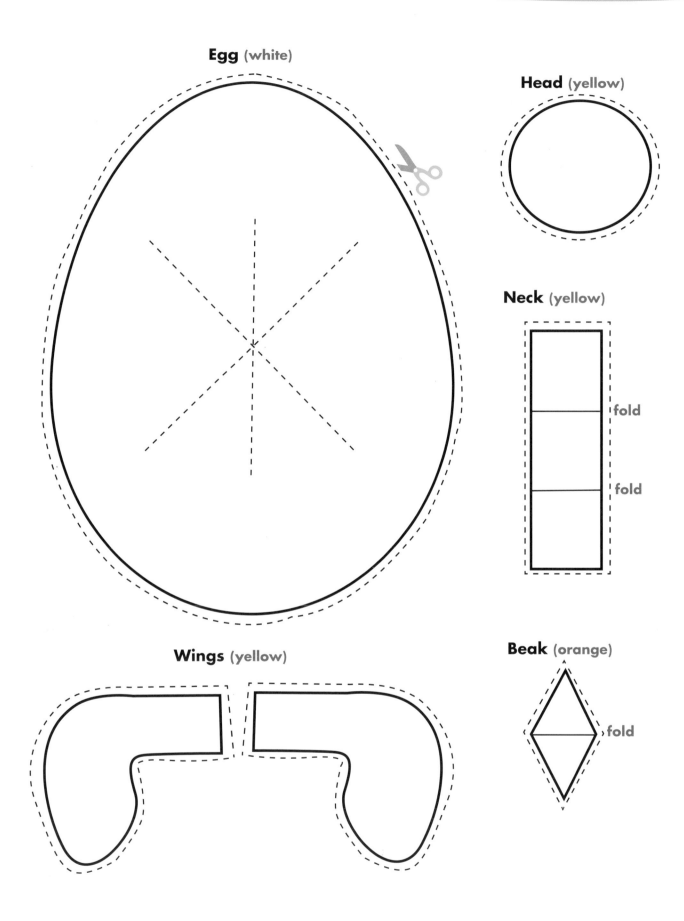

Egg (white)

Head (yellow)

Neck (yellow)

fold

fold

Wings (yellow)

Beak (orange)

fold

This activity makes use of recycled egg cartons. Encourage the children to add their own characters or flowers to the centrepiece. Objects could be regularly changed to keep the arrangement interesting.

Easter centrepiece

STEPS TO FOLLOW

1. Colour in and cut out the pattern pieces. Children may want to make more than one sheet of patterns.

2. Tape the bee and flowers to varied lengths of pipe cleaner. Make a centrally located hole in the egg carton with the end of the scissors. Insert the pipe cleaners into the hole. Bend the pipe cleaners to fan them out.

3. Glue the bunny, eggs and bird into the egg carton.

4. Distribute the grass around the items inside the egg carton.

MATERIALS

- a copy of photocopiable page 89 for each child

- bottom half of an egg carton

- shredded green paper to use as grass

- pipe cleaners

- crayons, felt-tip pens or coloured pencils

- scissors

- glue

- tape

National Curriculum: Art & design
KS1: 2a, 2b, 2c, 4a, 4b, 5b, 5c
QCA Schemes: Art & design
Unit 1B – Investigating materials
Unit 2B – Mother Nature, designer
Scottish 5-14 Guidelines: Art & design
Using materials, techniques, skills and media:
Investigating visually and recording; Using media; Using visual elements
Expressing feelings, ideas, thoughts and solutions: Creating and designing; Communicating

Flower

Tulip

Bunny

Chicks

Eggs

Bee

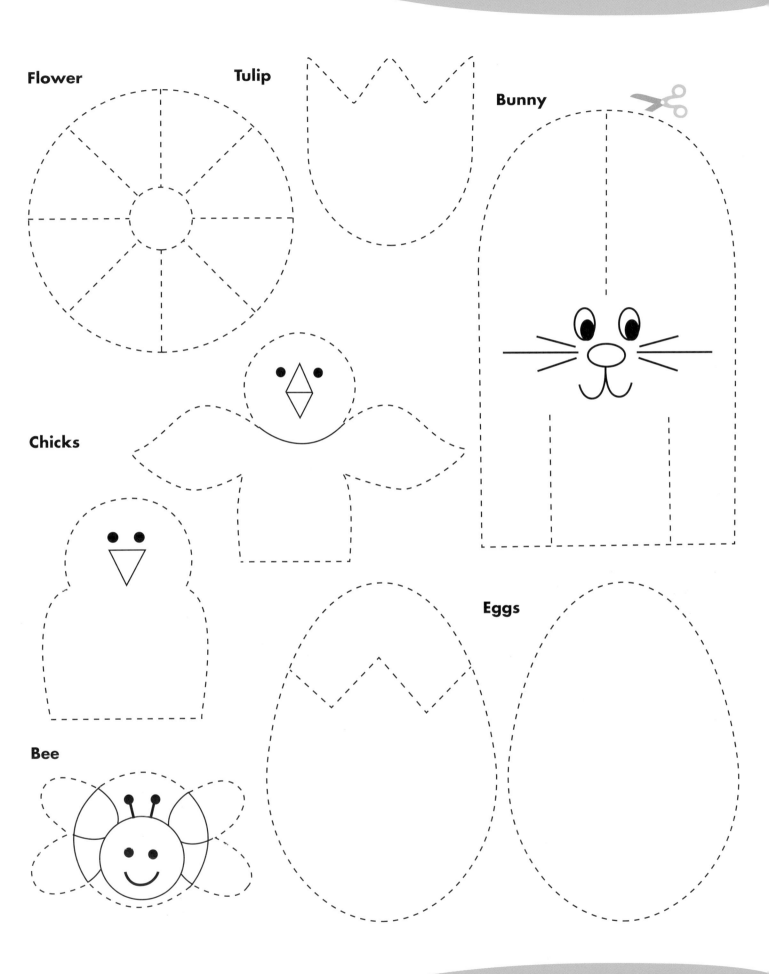

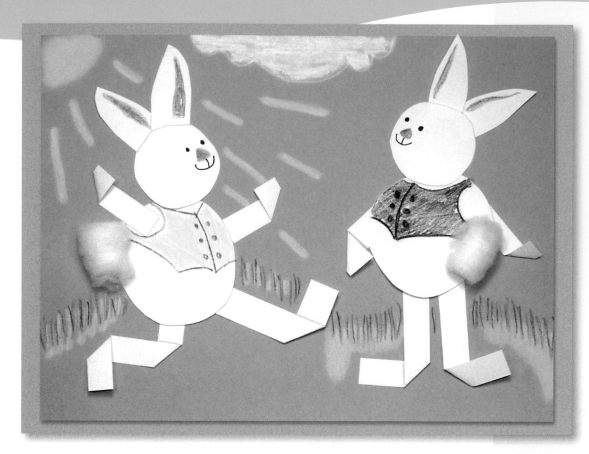

AGE RANGE:
5-11 years

This art project shows how to make a moveable picture. The bendable arms and legs made from white paper allow children to pose their bunnies in a variety of ways. They can experiment with putting the bunnies in different postures.

Busy bunnies

STEPS TO FOLLOW

1. Cut out the pattern pieces. Lay the bunny parts on the blue paper. Arrange them into two bunnies. The fun part is being able to bend the arms and legs to create different positions. Children should experiment with different postures.

2. Glue the parts in place when the children are happy with their arrangements.

3. Draw in details on the bunnies with crayons, felt-tip pens or coloured pencils. Also add details to the background.

4. Glue a cotton wool ball tail to each bunny.

5. Glue the blue paper to the pink frame.

MATERIALS

- a copy of photocopiable page 91 for each child

- 23 x 30.5 cm light blue card for the background

- 24 x 32 cm pink card for the frame

- 2 cotton wool balls

- crayons, felt-tip pens or coloured pencils

- scissors

- glue

National Curriculum: Art & design
KS1: 2a, 2b, 2c, 3b, 4a, 4b, 5b, 5c
KS2: 2a, 2b, 2c, 3b, 4a, 4b, 5b, 5c
QCA Schemes: Art & design
Unit 1B – Investigating materials
Unit 6A – People in action
Scottish 5-14 Guidelines: Art & design
Using materials, techniques, skills and media:
Using media; Using visual elements
Expressing feelings, ideas, thoughts and solutions: Creating and designing

Bunny 1

Bunny 2

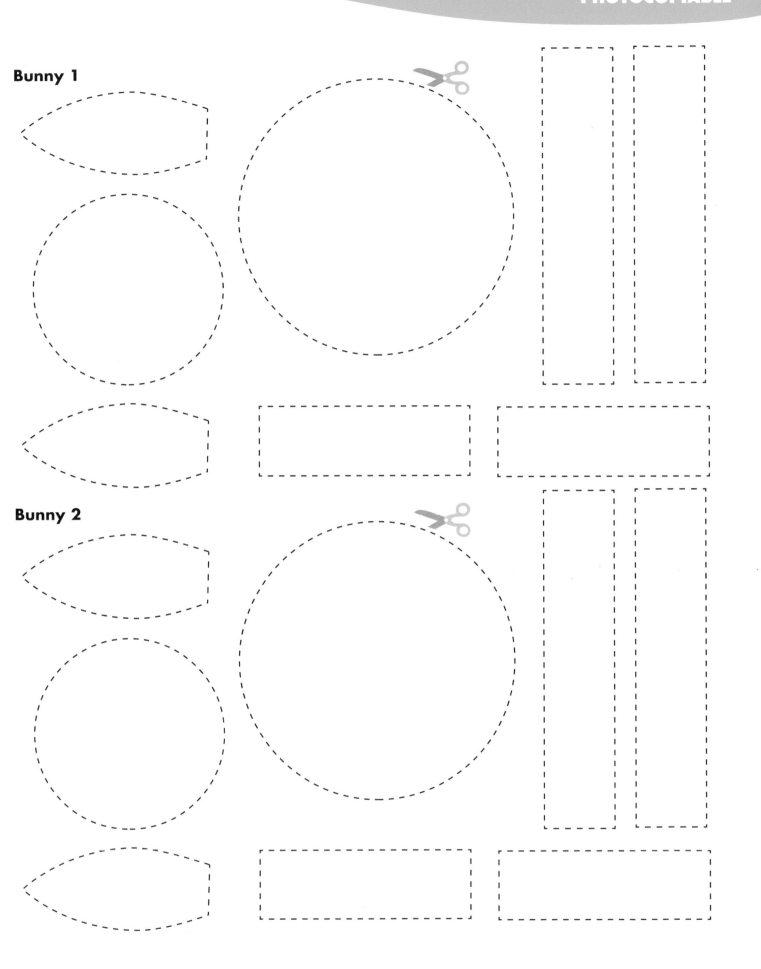

The cross-legged bunny

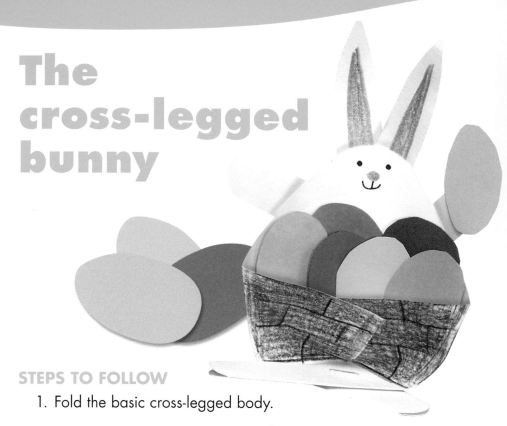

AGE RANGE: 5-11 years

This bunny has his own basket pocket to hold colourful eggs. Children use origami paper folding techniques to make the bunny's body. The eggs in the pocket could be used to hold maths facts or words used for literacy.

MATERIALS

- 15 cm square of white card for the cross-legged body
- 7.5 cm square of white card for the ears and arms
- 5 cm squares of coloured card for the eggs
- crayons, felt-tip pens or coloured pencils
- scissors
- glue
- stapler

STEPS TO FOLLOW

1. Fold the basic cross-legged body.

a.

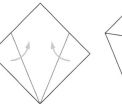

Fold into middle.

b.

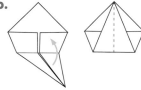

Fold up.

c.

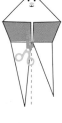

Cut up to the fold. Use crayons, felt-tip pens or coloured pencils to colour in the basket. Add facial features.

d.

Cross the bunny's legs and staple. Pull out the basket pieces and staple. Round off the top point and the feet.

2. Cut the ears and arms as shown. Colour the inner ears pink. Glue the arms and ears in place.

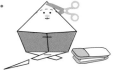

3. Cut egg shapes from the coloured squares. Place them in the bunny's pocket. Glue one in his paw.

National Curriculum: Art & design
KS1: 2a, 2b, 2c, 4a, 4b, 5b, 5c
KS2: 2a, 2b, 2c, 4a, 4b, 5b, 5c
QCA Schemes: Art & design
Unit 1B – Investigating materials
Unit 3B – Investigating pattern
Scottish 5-14 Guidelines: Art & design
Using materials, techniques, skills and media:
Using media; Using visual elements
Expressing feelings, ideas, thoughts and
solutions: Creating and designing

This simple bunny headband is made from a brown paper bag. Once the head band is made, encourage the children to design a bunny's face. The headbands could be used for a range of activities including story telling.

MATERIALS

- a brown paper bag with a flat bottom

- 2.5 cm squares of pink, white and black sugar paper for the nose and eyes

- scraps of black sugar paper for the whiskers

- crayons, felt-tip pens or coloured pencils

- scissors

- glue

- stapler

- pencil

National Curriculum: Art & design
KS1: 2a, 2b, 2c, 4a, 4b, 5b, 5c
KS2: 2a, 2b, 2c, 4a, 4b, 5b, 5c
QCA Schemes: Art & design
Unit 1B – Investigating materials
Scottish 5-14 Guidelines: Art & design
Using materials, techniques, skills and media: Using media; Using visual elements
Expressing feelings, ideas, thoughts and solutions: Creating and designing; Communicating

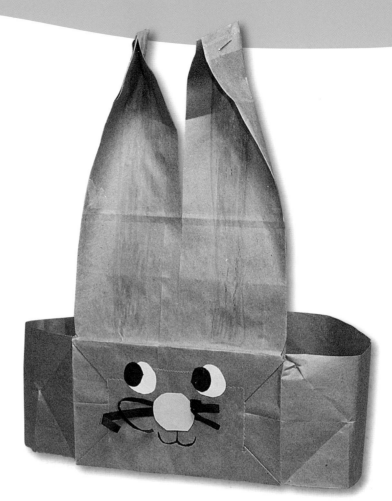

Bunny headband

STEPS TO FOLLOW

1. Cut the brown paper bag as shown.

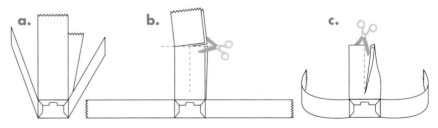

2. Cut down the centre panel for the ears. Trim off excess on the ears as shown.

3. Add a pink stripe down the centre of each ear.

4. Create the bunny's face by cutting the pink, white and black paper to create the eyes and nose. Cut and curl the whiskers and add a little mouth.

5. Pinch closed and staple the top of each ear.

6. Fit the headband to each child's head, remove and staple in place.

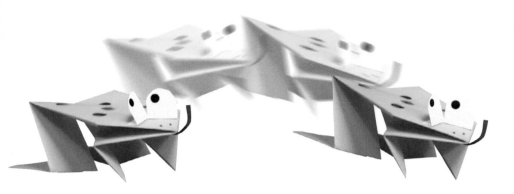

A jumping frog

Children can develop their paper-folding skills by making this fun jumping frog. They will have to fold carefully if the frog is to leap properly. Suggest a frog leaping contest once the frogs are made. This project links well with work on springs and forces.

MATERIALS

- 10 x 23 cm green paper for the frog's body

 Hint: Copy paper is the ideal weight for this project, but card may also be used.

- two 2 x 2.5 cm pieces of white card for the eyes

- scrap of red card for the tongue

- pencil with a new eraser

- tempera paint in assorted colours

- black marker pen

- scissors

- glue

STEPS TO FOLLOW

1. Fold the paper as shown to make the basic frog body.

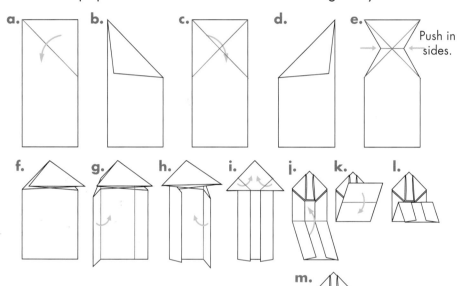

a. **b.** **c.** **d.** **e.** Push in sides.

f. **g.** **h.** **i.** **j.** **k.** **l.**

m.

2. Unfold the legs and cut up the centre to the second fold for the legs.

3. Round two corners on the pieces of white card for the eyes. Add eyeballs with the black marker pen. Fold down a flap on the other end. Glue the folded flap to the frog.

4. Add two nostrils with the black marker pen.

5. Cut a thin strip of red card for the tongue. Curl the tip with the pencil. Glue it in place.

6. Add spots to the frog's back by using the pencil eraser and tempera paint in a contrasting colour.

7. Stroke the frog's back and watch it jump!

National Curriculum: Art & design
KS2: 2a, 2b, 2c, 4a, 4b, 5b, 5c
Scottish 5-14 Guidelines: Art & design
Using materials, techniques, skills and media:
Investigating visually and recording; Using media; Using visual elements
Expressing feelings, ideas, thoughts and solutions: Creating and designing; Communicating

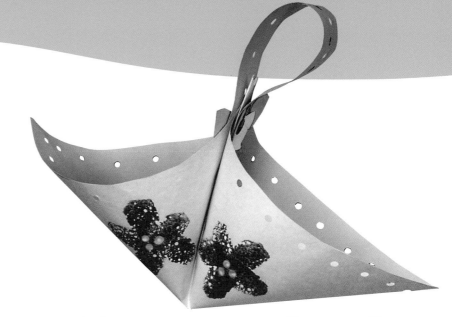

This May basket is designed using just one square of paper. Children learn how to carefully fold and pull paper into a shape. Once the baskets are made suggest that they are filled with paper flowers for a May Day celebration.

MATERIALS

- 30.5 cm square of pink card for the basket
- 5 x 30.5 cm strip of pink card for the handle
- 5 cm squares of yellow, magenta and green sugar paper for the flowers and leaves
- small petal-shaped sponge
- red and yellow tempera paint
- shallow dishes
- pencil with a new eraser
- hole punch
- stapler
- scissors
- glue

National Curriculum: Art & design
KS1: 2a, 2b, 2c, 4a, 4b, 5b, 5c
KS2: 2a, 2b, 2c, 4a, 4b, 5b, 5c
QCA Schemes: Art & design
Unit 1B – Investigating materials
Unit 5B – Containers
Scottish 5-14 Guidelines: Art & design
Using materials, techniques, skills and media:
Using media; Using visual elements
Expressing feelings, ideas, thoughts and
solutions: Creating and designing

A nifty May basket

STEPS TO FOLLOW

1. Fold the pink square paper into quarters as shown. Open it and mark an X in the centre. You will print on this side.

2. Dip the petal-shaped sponge into the red tempera paint and print one flower in each quarter of the pink paper. Let them dry.

3. Use the pencil eraser to print yellow centres in the flowers. Let them dry.

4. Lay the pink paper flower-side down. Notice that one fold is raised up from corner to corner. Pinch that fold together at one end and pull the fold up to the centre. Pinch and pull the opposite corner to the centre.

5. Use the hole punch to make lacy dots around the top edge of the basket sections.

6. Punch holes in the handle, too. Continue to decorate the handle by doing pencil-eraser printing with the red and yellow paint.

7. Bend and staple the two ends of the handle to the centre of the basket.

8. Cut flowers, centres and leaves from the small squares of card. Glue them on each side of the handle.

9. Fill the basket with flowers or greetings, and surprise a friend.

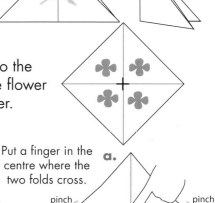

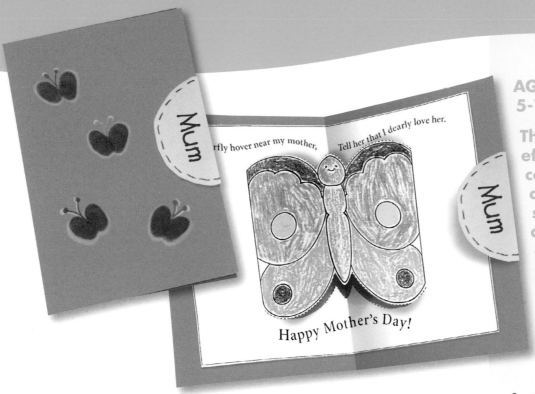

This is a simple but effective pop up card, which helps develop children's skills in using three-dimensional paper constructions. Ask the children to think of ways to decorate the front cover of the card.

MATERIALS

- a copy of photocopiable page 97 for each child
- 20 x 28 cm blue card for the card
- 7.5 cm square of yellow card for the clasp
- dark blue stamp pad
- crayons, felt-tip pens, or coloured pencils
- scissors
- glue

Mother's Day pop-up card

STEPS TO FOLLOW

1. Colour in the pattern. Cut out and fold the pop-up card pattern as shown.

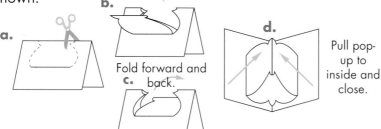

a.

b.

Fold forward and back.

c.

d.

Pull pop-up to inside and close.

2. Fold the blue card in half.

3. Use the blue stamp pad and fingers to make little butterflies on the front cover. Add details with crayons, felt-tip pens or coloured pencils.

4. Open the blue card. Lay the folded pop-up inside, close to the fold. Apply glue. Close the card and press firmly.

5. Flip the card over and open it. Apply glue to the other side of the pattern. Close the card and press.

6. Round off the corners of the yellow square for the clasp. Fold it in half, apply glue, and wrap around the open side of the card. Write 'Mum' on the front. It is ready for delivery!

National Curriculum: Art & design
KS1: 2a, 2b, 4a, 4b, 4c, 5b, 5c
KS2: 2a, 2b, 2c, 4a, 4b, 5b, 5c
QCA Schemes: Art & design
Unit 1B – Investigating materials
Scottish 5-14 Guidelines: Art & design
Using materials, techniques, skills and media:
Using media; Using visual elements
Expressing feelings, ideas, thoughts and solutions: Creating and designing

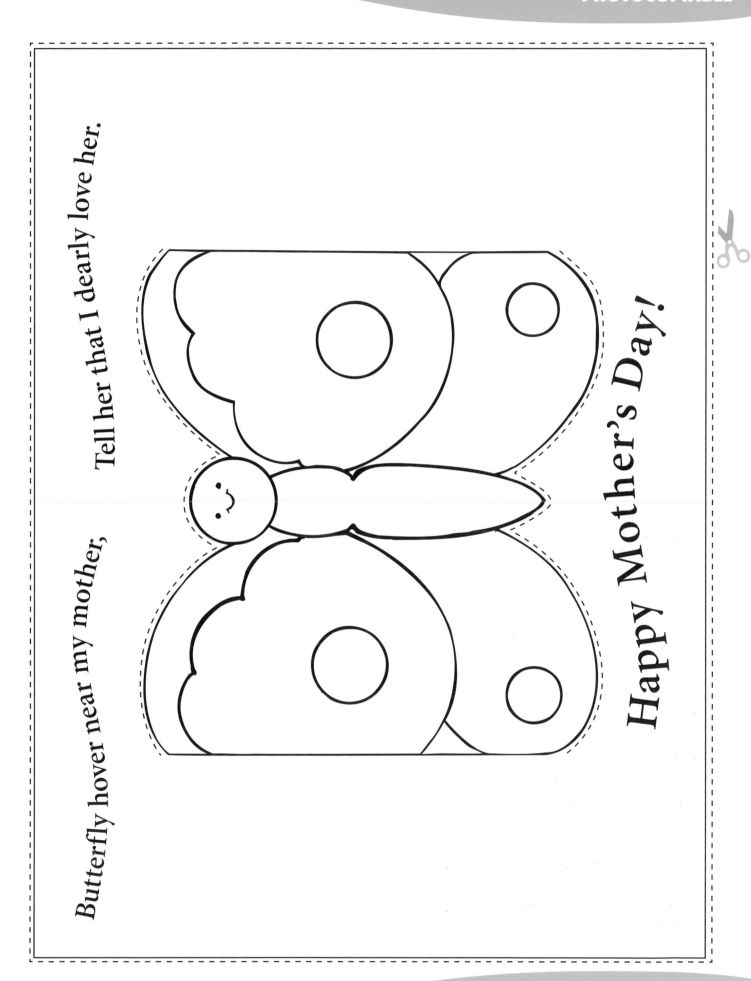

Butterfly hover near my mother,

Tell her that I dearly love her.

Happy Mother's Day!

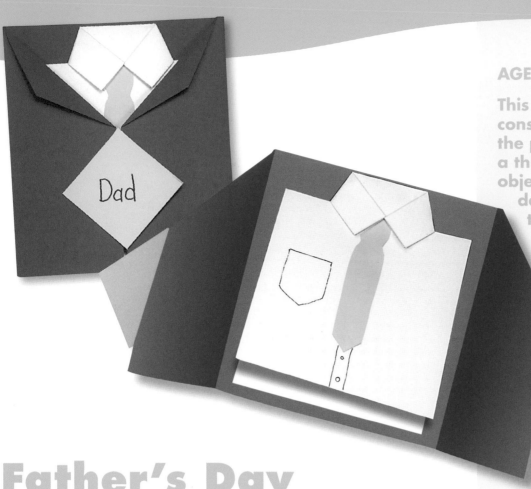

AGE RANGE: 5-11 years

This Father Day's card is constructed by folding the paper to make a three-dimensional object. Let the children design and decorate the ties and shirts so that the cards are all unique.

MATERIALS

- photocopiable page 99
- 15 x 26.5 cm blue card for the cover
- 7.5 x 10 cm yellow card for the tie and the cover seal
- scissors
- glue
- black fine-point marker pen

Father's Day card

STEPS TO FOLLOW

1. Cut out the shirt pattern. Fold and cut as shown.

2. Using the template as a guide, cut a tie from the yellow card. Glue it to the shirt. Add details with the black marker pen.

3. Fold and cut the blue card as shown.

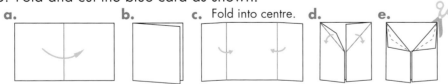

4. Glue the shirt inside the cover.

5. Cut out and glue the seal to the front and address it to Dad.

National Curriculum: Art & design
KS1: 2a, 2b, 2c, 4a, 4b, 5b, 5c
KS2: 2a, 2b, 2c, 4a, 4b, 5b, 5c
QCA Schemes: Art & design
Unit 1B – Investigating materials
Scottish 5-14 Guidelines: Art & design
Using materials, techniques, skills and media:
Using media; Using visual elements
Expressing feelings, ideas, thoughts and
solutions: Creating and designing

Father's Day card – pattern & templates

Seal (yellow)

SPRING

fold

fold

fold

cut

cut

Tie (yellow)

Contents

The summer is usually a time for holidays and outdoor activities. This is the season when the weather is warm and sunny. A lot of people go away for their holidays. Many people like to have a day at the seaside and play on the beach. Some people like to spend time in their gardens. It is the time of the year for circuses and fairs.

The art projects in this chapter focus on all these areas. Using collage, three-dimensional constructions, building up landscapes and folding paper, children have an opportunity to bring the summer into the classroom.

The final project of the chapter uses recyclable card and paper bags to make a summer memories book. It would also be perfect as a class visit book.

The projects use a wide range of art and craft techniques such as paper folding, cutting, collage, exploring textures and using recyclables.

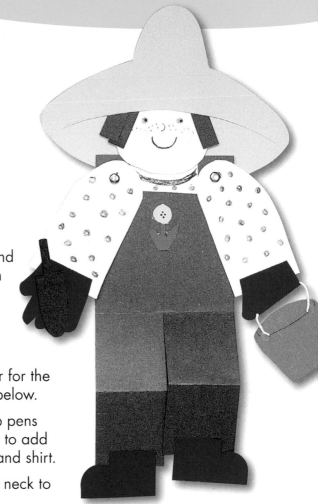

AGE RANGE: 5-11 years

The gardener in this activity has moveable arms and uses simple paper folding techniques to create bendable legs.

MATERIALS

- photocopiable pages 102 and 103
- 10 x 23 cm blue card for the overalls
- 15 x 20 cm yellow card for the hat
- 15 x 30.5 cm white card for the face and shirt
- 5 x 25.5 cm red card for the gloves and boots
- 5 cm square of brown card for the hair
- 4 x 9 cm black card for the trowel
- 6 x 7.5 cm green card for the bucket
- scraps of card for adding details
- 2 paper fasteners
- scissors and craft knife
- glue and tape
- crayons, felt-tip pens or coloured pencils
- hole punch
- string

National Curriculum: Art & design
KS1: 2a, 2b, 2c, 4a, 4b, 5b, 5c
KS2: 2a, 2b, 2c, 4a, 4b, 5b, 5c

QCA Schemes: Art & design
Unit 1A – Self portrait
Unit 1B – Investigating materials
Unit 6A – People in action

Scottish 5-14 Guidelines: Art & design
Using materials, techniques, skills and media:
Using media; Using visual elements
Expressing feelings, ideas, thoughts
and solutions: Creating and designing;
Communicating

In the garden

STEPS TO FOLLOW

1. Trace and cut around all the templates on the appropriate colours of card. Punch holes as indicated.

2. Fold the blue paper for the overalls as shown below.

3. Use crayons, felt-tip pens or coloured pencils to add details to the face and shirt.

4. Glue the head and neck to the overalls.

5. Cut the slit in the hat with a craft knife. Slip the hat over the head. Tape in the back.

6. Cut the brown paper into four strips. Glue two on each side of the head under the hat for hair.

7. Attach the arms to the overalls with the paper fasteners.

8. Glue the gloves and boots to the gardener.

9. Glue the trowel onto one glove. Punch holes in the bucket and insert a length of string. Tie the ends together. Fold the other glove over the basket handle and tape it down.

10. Add other details with scraps of paper, crayons, felt-tip pens or coloured pencils.

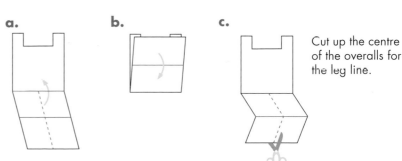

a.　　**b.**　　**c.**

Cut up the centre of the overalls for the leg line.

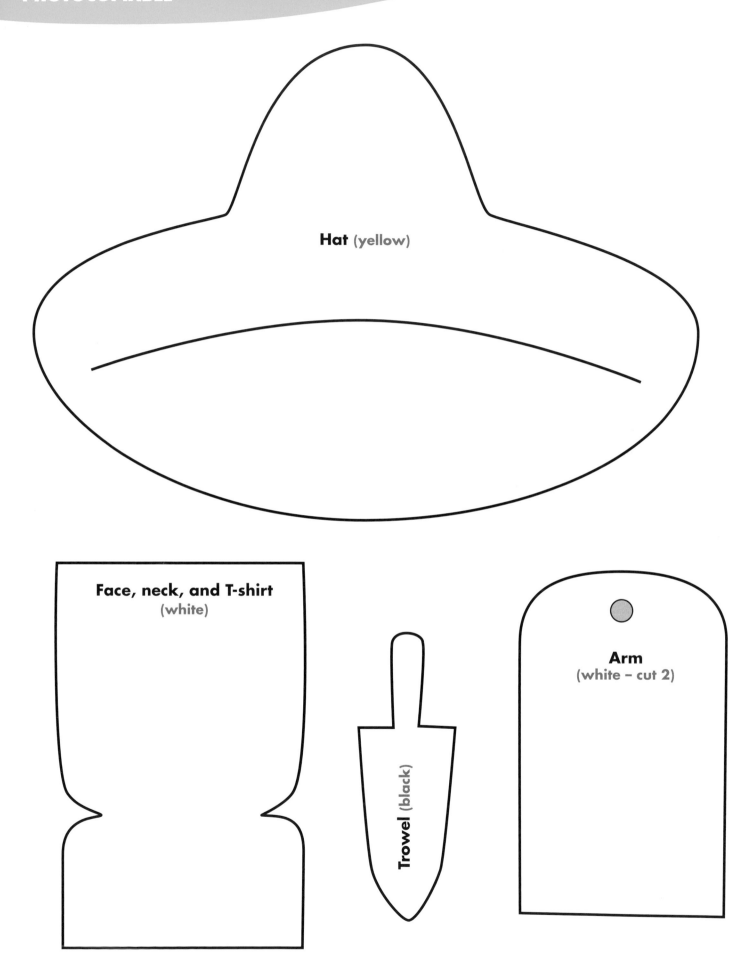

Hat (yellow)

Face, neck, and T-shirt
(white)

Trowel (black)

Arm
(white – cut 2)

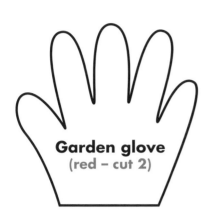

Garden glove
(red – cut 2)

Overalls
(blue)

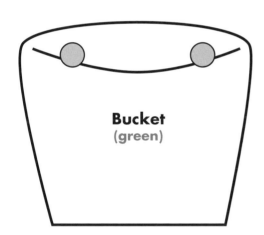

Bucket
(green)

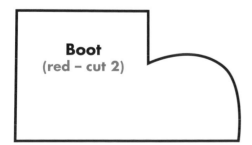

Boot
(red – cut 2)

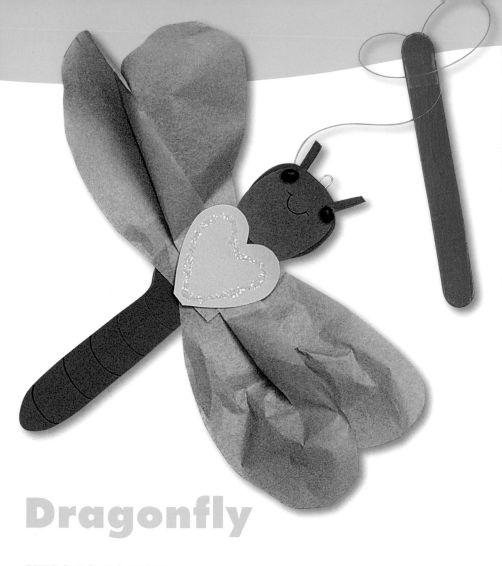

Dragonfly

STEPS TO FOLLOW

1. Trace around the body template onto the thick blue card. Cut it out and add details with a black marker, coloured pencil or crayon.

2. Glue on the beans for eyes.

3. Tape the paper clip to the back of the face.

4. Make four pink tissue paper wings using the template as a guide. Place two on each side of the body. Make one pleat in the wings and then staple to the centre section.

5. Cut out a yellow heart to glue over where the wings are attached. Add glitter to the heart to give it some sparkle.

6. Tie the fishing line to the paper clip. Tape the other end to the craft stick for a handle.

AGE RANGE: 5-11 years

This attractive and simple activity fits in well alongside a minibeast project. Let the children enjoy the dragonflies as miniature kites to fly around the playground.

MATERIALS

- photocopiable page 105
- 6 x 23 cm thick blue card
- four 10 x 18 cm pieces of pink tissue paper for the wings
- 7.5 cm square of yellow card for the heart
- two black beans
- paper clip
- 45.5 cm length of clear plastic fishing line
- craft stick
- glitter
- scissors
- glue
- tape
- crayons, felt-tip pens or coloured pencils
- stapler

National Curriculum: Art & design
KS1: 2a, 2b, 2c, 4a, 4b, 5b, 5c
KS2: 2a, 2b, 2c, 4a, 4b, 5b, 5c
QCA Schemes: Art & design
Unit 1B – Investigating materials
Unit 2B – Mother Nature, designer
Scottish 5-14 Guidelines: Art & design
Using materials, techniques, skills and media: Using media; Using visual elements
Expressing feelings, ideas, thoughts and solutions: Creating and designing

Body

(blue)

Wings

(pink – cut 4)

Heart

(yellow)

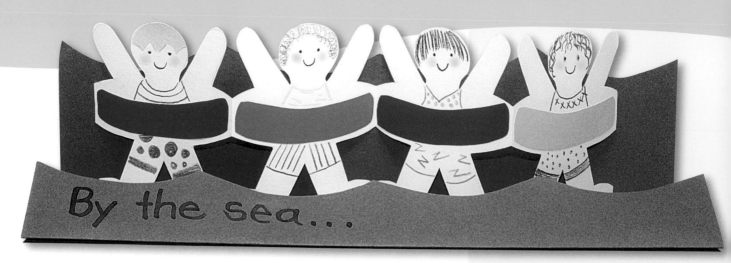

By the sea

AGE RANGE: 5-7 years

These swimmers are made by cutting folded paper into a chain. Encourage children to design and decorate each figure.

STEPS TO FOLLOW

1. Fold the white card like an accordion as shown.

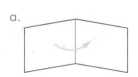

2. Trace the chain template onto the folded card. Cut on the lines.

3. Use the template to trace the inner tubes on the colourful pieces of sugar paper. Cut them out and glue them in place on the chain.

4. Colour the chain of swimmers, making each one unique.

5. Fold the blue card as shown.

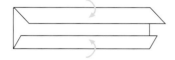

6. Cut a wave border on the top and bottom of the paper.

7. Print 'By the sea...' along the front wave. Place the chain of swimmers between the two waves.

MATERIALS

- photocopiable page 107
- 14 x 45.5 cm white card for the chain
- 30.5 x 45.5 cm blue card for the ocean waves
- 5 x 12.5 cm red, yellow, blue and orange sugar paper for the inner tubes
- scissors
- glue
- crayons, felt-tip pens or coloured pencils

National Curriculum: Art & design
KS1: 2a, 2b, 2c, 4a, 4b, 5b, 5c
KS2: 2a, 2b, 2c, 4a, 4b, 5b, 5c
QCA Schemes: Art & design
Unit 1B – Investigating materials
Unit 3B – Investigating pattern
Scottish 5-14 Guidelines: Art & design
Using materials, techniques, skills and media:
Using media; Using visual elements
Expressing feelings, ideas, thoughts and solutions: Creating and designing

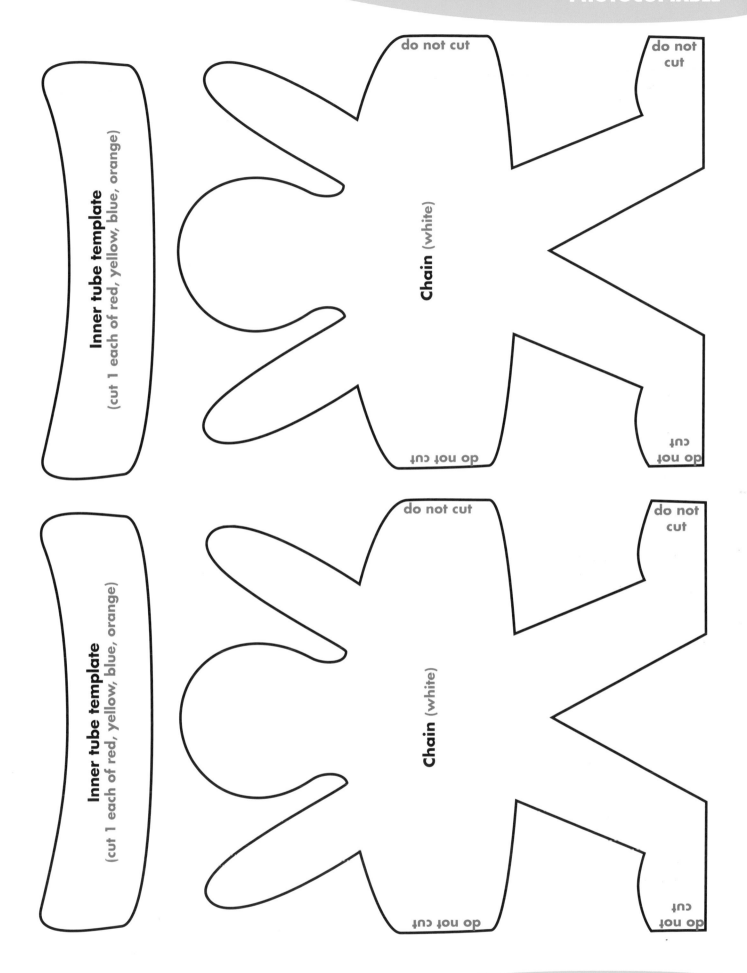

Inner tube template
(cut 1 each of red, yellow, blue, orange)

Chain (white)

do not cut

do not cut

do not cut

do not cut

Inner tube template
(cut 1 each of red, yellow, blue, orange)

Chain (white)

do not cut

do not cut

do not cut

do not cut

Seascape

STEPS TO FOLLOW

1. Cut out a circle from the orange card.

2. Tear a rippled line along one side of the yellow card.

3. Lay the dark blue sea, the yellow sand, and the orange sun on the light blue card.

4. Dip the edge of the corrugated cardboard in the white paint. Print white ripples on the dark blue water.

5. Colour in and cut out the three umbrellas. Experiment with stripes, polka dots and colour combinations. Make them colourful and bright.

6. Lay the black poles on the picture. Cut them to the desired lengths. Lay the umbrellas on the poles.

7. Glue all parts in place.

8. Add any other details with crayons, felt-tip pens or coloured pencils.

AGE RANGE: 5-11 years

This activity shows how to build up a collage in layers. It also offers an opportunity to discuss different design possibilities. Encourage children to experiment with repeated shapes and colours to develop interesting variations.

MATERIALS

- a copy of photocopiable page 109 for each child

- 23 x 30.5 cm light blue card for the background

- 15 x 30.5 cm dark blue card for the sea

- 5 x 30.5 cm yellow card for the sand

- 7.5 cm square of orange card for the sun

- three 0.6 x 23 cm black card strips for the poles

- white tempera paint

- shallow dish

- strip of corrugated cardboard

- crayons, felt-tip pens or coloured pencils

- glue

- scissors

National Curriculum: Art & design
KS1: 2a, 2b, 2c, 4a, 4b, 5b, 5c
KS2: 2a, 2b, 2c, 4a, 4b, 5b, 5c
QCA Schemes: Art & design
Unit 1B – Investigating materials
Scottish 5-14 Guidelines: Art & design
Using materials, techniques, skills and media: Investigating visually and recording; Using media; Using visual elements
Expressing feelings, ideas, thoughts and solutions: Creating and designing

Umbrellas

Snorkel time

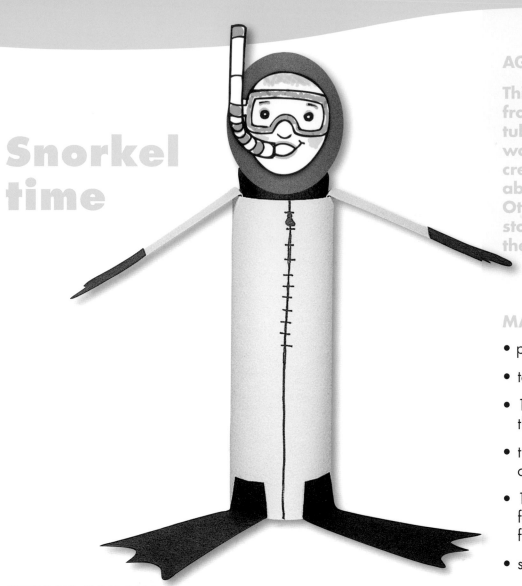

AGE RANGE: 5-11 years

This fun figure is made from a simple toilet tissue tube. This activity is a wonderful lead-in to a creative writing session about the snorkeller. Other characters in the story can be made using the same techniques.

MATERIALS

- photocopiable page 111
- toilet tissue tube
- 12.5 x 15 cm yellow card for the body suit
- two 1.25 x 14 cm yellow card strips for the arms
- 15 cm square of black card for the torso, gloves and flippers
- scissors
- glue or tape
- crayons, felt-tip pens or coloured pencils

STEPS TO FOLLOW

1. Draw the zipper and leg line as shown on the larger yellow card.

2. Wrap the tube with the yellow card. Tape or glue it in place.

3. Trace and cut out the template pieces on the black card for the torso, gloves and flippers.

4. Fold the two yellow strips in half and glue a glove to one end of each arm.

5. Colour in and cut out the pattern for the face and snorkel. Glue it to the head.

6. Roll the torso so that it fits into the top of the tube. Also insert the arm strips on each side of the torso and bend them out and down.

7. Fold up a flap on the end of each flipper. Glue the flaps to the tube.

National Curriculum: Art & design
KS1: 2a, 2b, 2c, 4a, 4b, 5b, 5c
KS2: 2a, 2b, 2c, 4a, 4b, 5b, 5c
QCA Schemes: Art & design
Unit 1B – Investigating materials
Scottish 5-14 Guidelines: Art & design
Using materials, techniques, skills and media:
Using media; Using visual elements
Expressing feelings, ideas, thoughts and solutions: Creating and designing

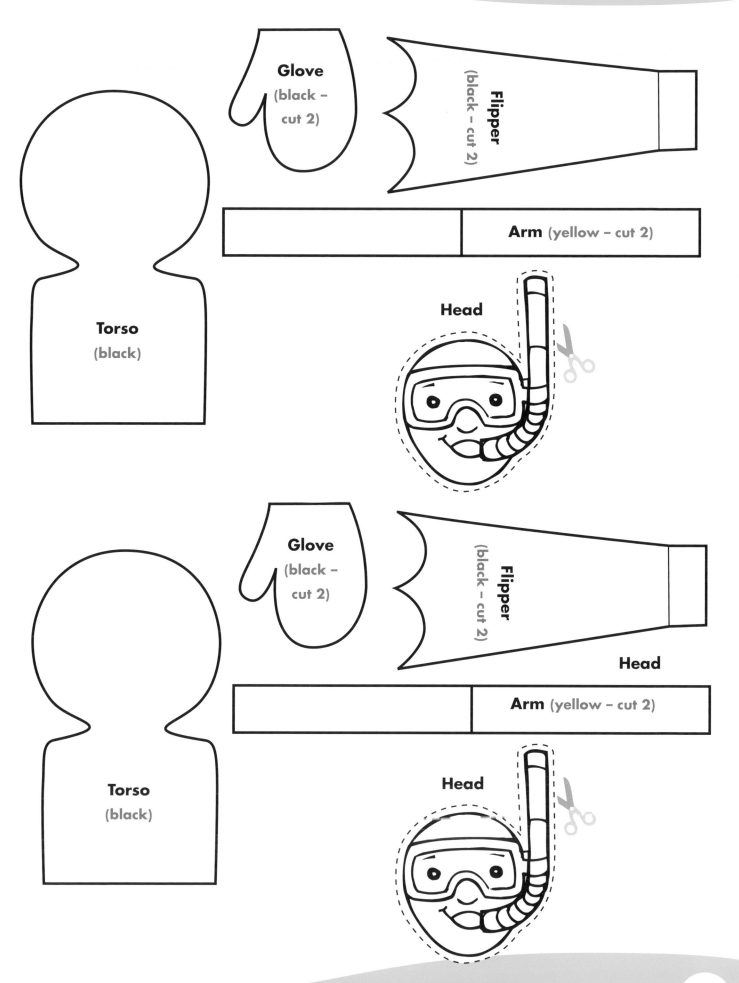

Glove (black – cut 2)

Flipper (black – cut 2)

Torso (black)

Arm (yellow – cut 2)

Head

Glove (black – cut 2)

Flipper (black – cut 2)

Head

Torso (black)

Arm (yellow – cut 2)

Head

Colourful fish

STEPS TO FOLLOW

1. Trace the fish template on each coloured square of card. Cut them out.

2. Draw an eye for each fish.

3. Punch a hole for a mouth.

4. Draw a centre stripe on the yellow fish. Hold all the fish together and cut out the stripe.

5. Lay all the fish and their parts on the blue paper. Mix and match the colour stripes so that each fish has one that is a contrasting colour. Glue all the pieces in place.

6. Punch bubbles coming from each fish's mouth.

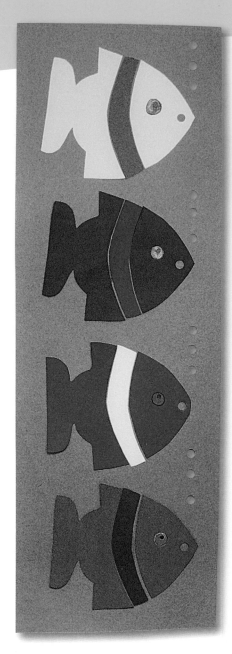

MATERIALS

- photocopiable page 113
- 15 x 45.5 cm dark blue card for the background
- 12.5 cm squares of yellow, red, orange, and purple card for the fish
- hole punch
- scissors
- glue
- crayons, felt-tip pens or coloured pencils
- pencil

National Curriculum: Art & design
KS1: 2a, 2b, 2c, 4a, 4b, 5b, 5c
QCA Schemes: Art & design
Unit 1B – Investigating materials
Unit 2B – Mother Nature, designer
Scottish 5-14 Guidelines: Art & design
Using materials, techniques, skills and media: Using media; Using visual elements
Expressing feelings, ideas, thoughts and solutions: Creating and designing

Fish
(yellow, orange, red, purple)

Fish
(yellow, orange, red, purple)

Fish
(yellow, orange, red, purple)

Fish
(yellow, orange, red, purple)

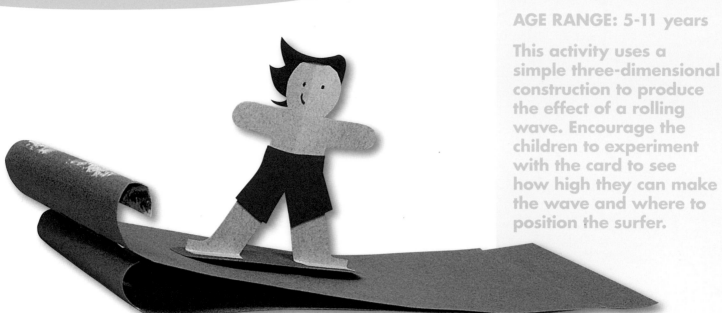

AGE RANGE: 5-11 years

This activity uses a simple three-dimensional construction to produce the effect of a rolling wave. Encourage the children to experiment with the card to see how high they can make the wave and where to position the surfer.

Surf's up

STEPS TO FOLLOW

1. Dip the sponge in the white paint. Sponge paint one end of each of the blue strips of card to create the white foam of a crashing wave. Allow to dry.

2. Trace around and cut out the templates for the body and the surfboard.

3. Use the card to make hair and a swimsuit. Glue it on. Add other details with crayons, felt-tip pens or coloured pencils.

4. Decorate the surfboard with scraps of paper.

5. Fold up a flap on the feet of the surfer. Glue the flaps to the surfboard.

6. Using a pen or pencil, curl the sponge-painted ends of the blue strips. Use double-sided sticky tape to secure one piece of the paper to the other. Let the top sheet buckle up to resemble a wave.

7. Use double-sided sticky tape to position the surfer on the wave.

MATERIALS

- photocopiable page 115
- two 10 x 30.5 cm strips of dark blue card for the water
- 5 x 12.5 cm brown card for the surfboard
- 12.5 cm square of flesh-coloured card for the surfer
- 5 cm square of black, yellow, red or brown card for the hair
- 7.5 cm squares of coloured card for the swimsuit
- double-sided sticky tape
- crayons, felt-tip pens or coloured pencils
- white tempera paint in a shallow dish
- small piece of sponge

National Curriculum: Art & design
KS1: 2a, 2b, 3b, 4a, 4b, 5b, 5c
KS2: 2a, 2b, 2c, 4a, 4b, 5b, 5c
QCA Schemes: Art & design
Unit 1B – Investigating materials
Scottish 5-14 Guidelines: Art & design
Using materials, techniques, skills and media:
Using media; Using visual elements
Expressing feelings, ideas, thoughts and
solutions: Creating and designing

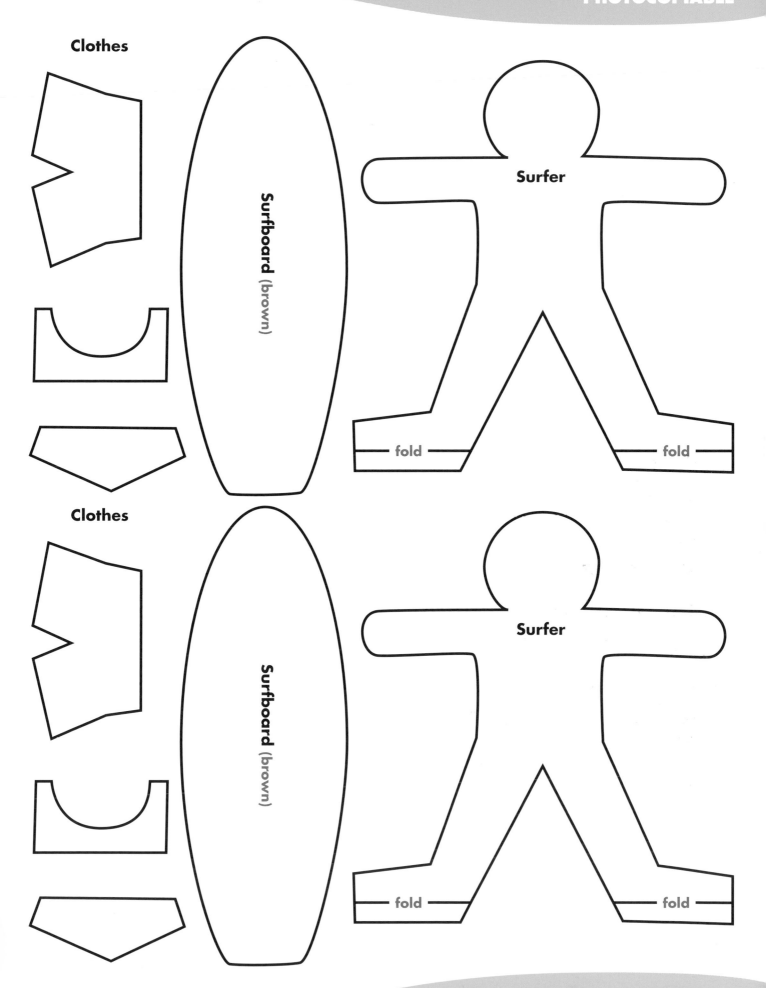

Clothes

Surfboard (brown)

Surfer

fold

fold

Clothes

Surfboard (brown)

Surfer

fold

fold

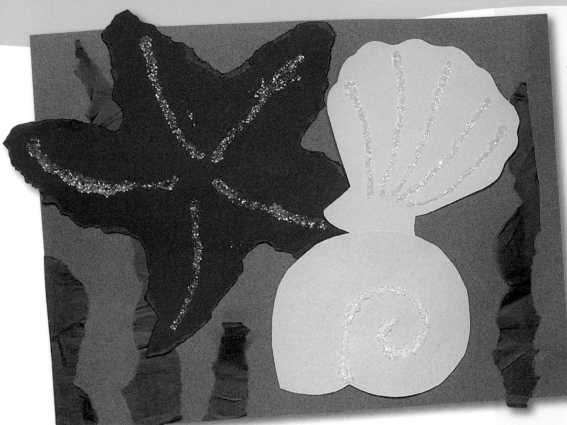

AGE RANGE:
5-7 years

This sea collage uses a range of effects to make an attractive picture. Twisted green tissue paper creates an interesting three-dimensional effect to the overall picture. Encourage the children to make extra shell shapes to add to the collage.

MATERIALS

- photocopiable pages 117 and 118
- 23 x 30.5 cm blue card for the background
- 23 cm square of orange card
- 14 cm square of yellow card
- 12.5 cm square of pink card
- strips of green tissue paper
- glitter
- pencil
- glue
- scissors

Below the sea

STEPS TO FOLLOW

1. Tear green tissue paper strips to glue to the blue card.

2. Trace around the shell templates on the colours of card specified.

3. Tear out the sea star.

4. Cut out the scallop and the conch shell.

5. Use glue and glitter to add details to the shells.

6. Arrange the shells and glue them to the blue paper. For an interesting effect, allow parts of the shells to extend off the paper.

National Curriculum: Art & design
KS1: 2a, 2b, 2c, 4a, 4b, 5b, 5c

QCA Schemes: Art & design
Unit 1B – Investigating materials
Unit 2B – Mother Nature, designer

Scottish 5-14 Guidelines: Art & design
Using materials, techniques, skills and media:
Investigating visually and recording; Using media; Using visual elements
Expressing feelings, ideas, thoughts and solutions: Creating and designing
Communicating

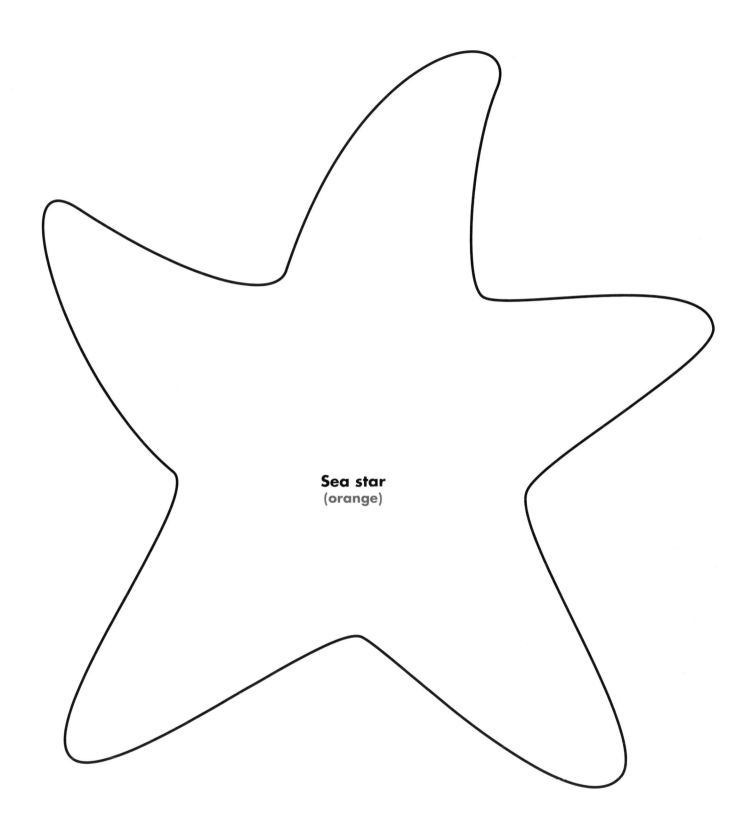

Sea star
(orange)

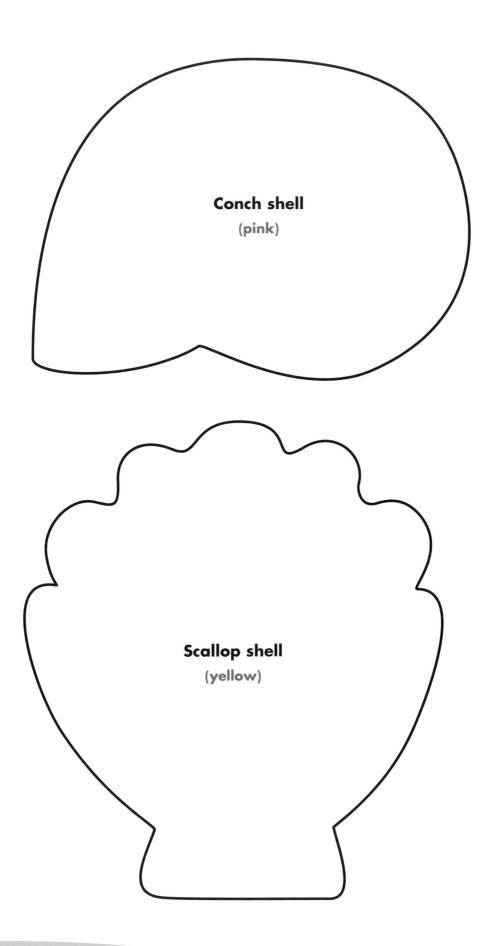

Conch shell

(pink)

Scallop shell

(yellow)

This activity has a pull-through strip to give the impression of moving clowns. Children will also learn the skills of careful cutting and folding. Extend the moving picture idea by suggesting other circus acts.

MATERIALS

- photocopiable pages 120 and 121
- 23 x 30.5 cm yellow card for the tent
- 12.5 x 45.5 cm yellow card for the pull-through strip
- 23 x 30.5 cm dark blue card for the tent top
- 5 x 10 cm red card for the flag
- craft stick
- scissors
- glue and tape
- craft knife
- crayons, felt-tip pens or coloured pencils

National Curriculum: Art & design
KS1: 2a, 2b, 2c, 4a, 4b, 5b, 5c
KS2: 2a, 2b, 2c, 4a, 4b, 5b, 5c
QCA Schemes: Art & design
Unit 1B – Investigating materials
Unit 6A – People in action
Scottish 5-14 Guidelines: Art & design
Using materials, techniques, skills and media:
Using media; Using visual elements
Expressing feelings, ideas, thoughts and
solutions: Creating and designing

Under the big top

Under the Big Top

STEPS TO FOLLOW

1. Cut the two vertical 12.5 cm slits in the yellow tent card as shown. Insert the pull-through strip.

2. Colour in and cut out the clown patterns.

3. Glue the clowns on the pull strip as you progressively pull it through the opening.

4. Colour in the tent top pattern. Glue it to the edge of the blue card. Trim around the scalloped edge.

5. Fold down the top corners of the blue card to create the peaked tent top. Glue it to the top of the yellow tent card.

6. Using the template as a guide, cut the flag from the red card. Glue it to the craft stick. Tape the stick to the back of the tent top.

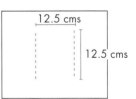

Clowns

Under the Big Top

Under the Big Top

Flag
(red)

Flag
(red)

On the merry-go-round

AGE RANGE: 5-11 years

This activity allows the children to build up a model after first making all the individual parts. Let the children experiment with colour and design to make the merry-go-round more decorative. This activity could also be used as part of a design and technology project.

MATERIALS

- copies of photocopiable pages 123 and 124 for each child
- 15 x 45.5 cm yellow card for the merry-go-round
- four 1.25 x 15 cm black card strips for the poles
- 20 cm square of bright blue card for the frame
- hole punch
- scissors
- glue
- crayons, felt-tip pens or coloured pencils
- glitter

STEPS TO FOLLOW

1. Colour in and cut out the horse patterns.

2. Punch a border of holes along the top edge of the yellow strip.

3. Use glue and glitter to make a sparkly border along the bottom of the yellow strip.

4. Lay out the black poles on the merry-go-round, varying the heights.

5. Lay the horses on the black poles. Distribute them evenly along the strip. Glue the poles and the horses in place.

6. Roll the yellow card into a cylinder with 2.5 cm overlap and glue to secure.

7. Colour in and cut out the base pattern. Glue it to the blue card. Trim the blue so a border remains. Stand the merry-go-round in the centre of the base.

National Curriculum: Art & design
KS1: 2a, 2b, 2c, 4a, 4b, 5b, 5c
KS2: 2a, 2b, 2c, 4a, 4b, 5b, 5c
QCA Schemes: Art & design
Unit 1B – Investigating materials
Scottish 5-14 Guidelines: Art & design
Using materials, techniques, skills and media:
Using media; Using visual elements
Expressing feelings, ideas, thoughts and
solutions: Creating and designing

SCHOLASTIC

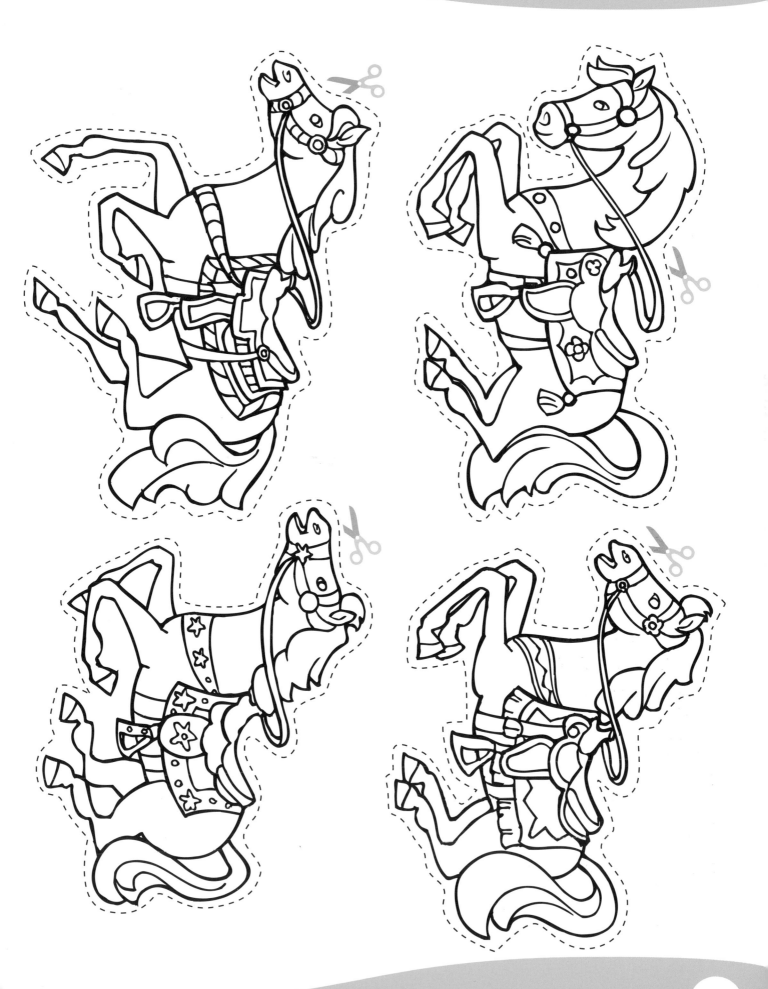

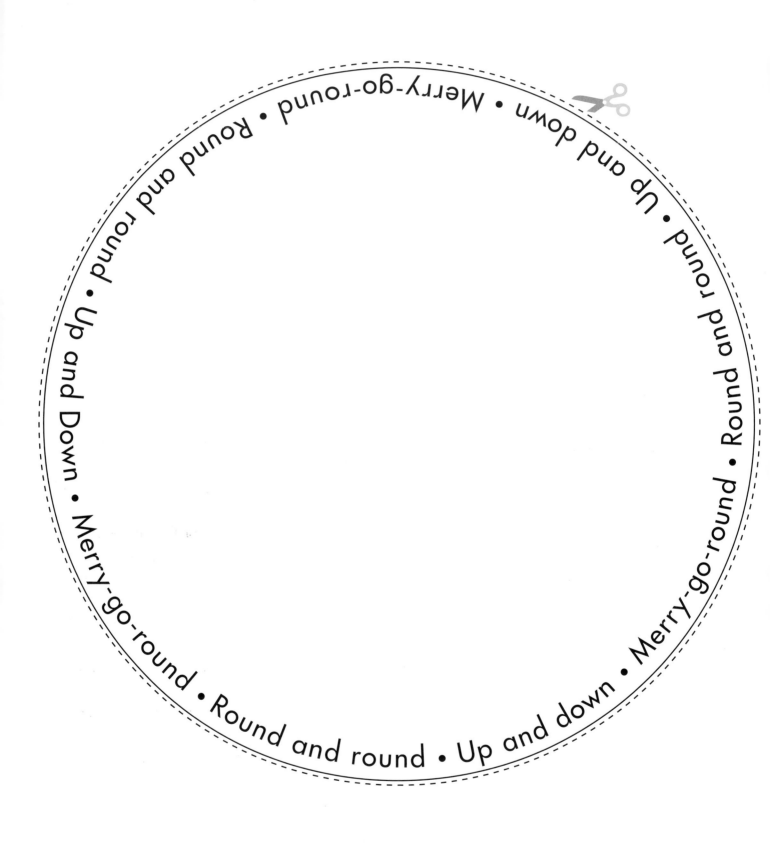

This activity highlights how a few simple paper folds can make a picture more interesting and interactive. Use the picture as a starting point for a story writing session.

MATERIALS

- photocopiable page 126
- 15 x 18 cm brown wrapping paper for the tent
- 23 x 30.5 cm dark blue card for the background
- 10 x 12.5 cm black card for the tent pieces
- 6 cm square of yellow card for the moon
- 6 x 30.5 cm green card strip for the grass
- 24 x 32 cm yellow card for the frame
- foil star stickers
- scissors
- glue
- crayons, felt-tip pens or coloured pencils

National Curriculum: Art & design
KS1: 2a, 2b, 2c, 4a, 4b, 5b, 5c
KS2: 2a, 2b, 2c, 4a, 4b, 5b, 5c
QCA Schemes: Art & design
Unit 1B – Investigating materials
Unit 3A – Portraying relationships
Scottish 5-14 Guidelines: Art & design
Using materials, techniques, skills and media:
Using media; Using visual elements
Expressing feelings, ideas, thoughts and
solutions: Creating and designing

Camping

STEPS TO FOLLOW

1. Cut a zigzag edge on the green strip for grass. Glue it to the bottom of the blue card.

2. Trace and cut out the tent template. Cut up the centre line and fold as indicated.

3. Cut a narrow strip from the black card for the tent supports.

4. Lay the rest of the black card and the brown wrapping paper on the background for the tent. Glue in place. Also glue on the tent supports.

5. Using the template as a guide, cut a moon shape from the yellow card. Glue it in the sky.

6. Colour in and cut out the campfire and camper patterns. Glue the campfire to one side of the tent.

7. Who is in the tent? Pick one of the patterns and glue it inside the flaps.

8. Finish the picture by placing a few star stickers in the sky.

Campfire

Child – camper 1

Bear – camper 2

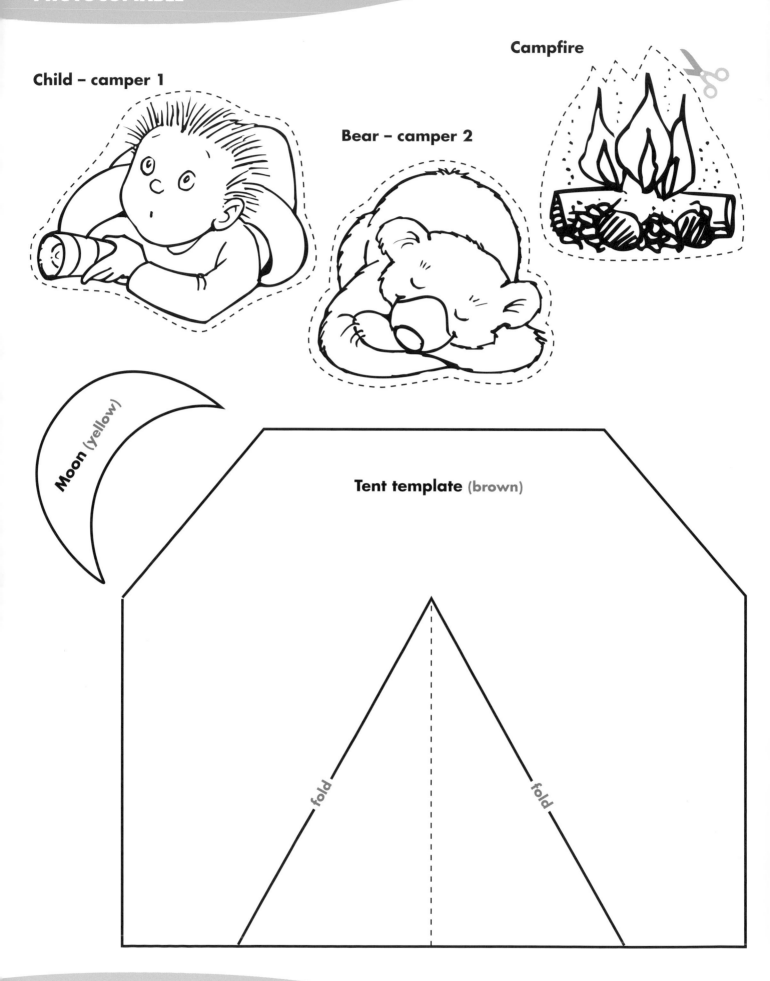

Moon (yellow)

Tent template (brown)

fold

fold

AGE RANGE: 7-11 years

This very effective memories book is made from paper bags. It shows the children how they can make something of use out of everyday objects. Children can make their own books to be used as diaries or a class book can be made to display recounts of a school trip or other events.

MATERIALS

- a copy of photocopiable page 128 for each child
- brown paper bags
- 12.5 x 20 cm coloured card for each bag in the book
- scraps of card
- wool or string
- scissors
- glue
- hole punch
- crayons, felt-tip pens or coloured pencils

National Curriculum: Art & design
KS1: 2a, 2b, 2c, 4a, 4b, 5b, 5c
KS2: 2a, 2b, 2c, 4a, 4b, 5b, 5c

QCA Schemes: Art & design
Unit 1B – Investigating materials
Unit 5C – Talking textiles

Scottish 5-14 Guidelines: Art & design
Using materials, techniques, skills and media:
Using media; Using visual elements
Expressing feelings, ideas, thoughts
and solutions: Creating and designing;
Communicating

Summer memories book

STEPS TO FOLLOW

1. Create a picture and a diary page for each memory bag in the book.

2. Glue the diary page to the bag. Glue the picture frame, with your photo, to the card that slips inside the bag as shown.

3. Design one bag as the cover. Use scraps of paper and crayons, felt-tip pens or coloured pencils to create the desired effect. Use the inside front cover of the book as a table of contents.

4. Punch two holes on the left side of all the bags. Bind the bags together with wool or string. Finish it by tying a bow.

Picture frame

glue photo here

Diary page

Date: _____